LEGENDAR'

OF

SALEM

MASSACHUSETTS

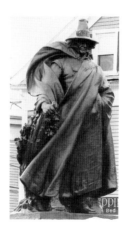

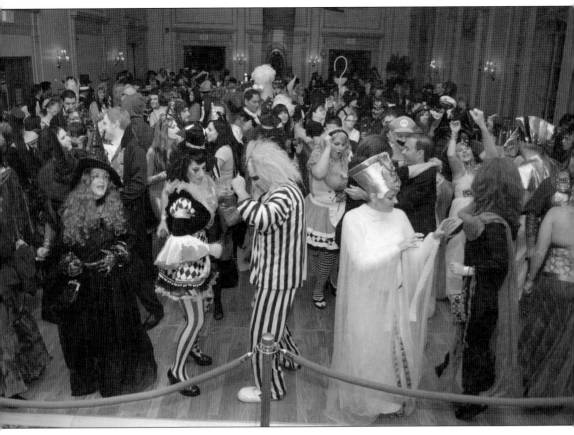

Haunted Happenings

The Halloween Masquerade Ball is held each year at the Hawthorne Hotel (see page 64). During this event, partygoers morph into the realm of the bizarre and engage in macabre and fun festivities on All Hallows' Eve—a highlight of Salem's year. (Courtesy of Hawthorne Hotel.)

Page 1: Roger Conant

Often mistaken for a statue of a witch because of its proximity to the Witch Museum, this is actually a statue of Salem's Puritan founder, Roger Conant. This sculpture, by Henry Hudson Kitson, was donated to Salem in 1913 by the Conant Family Association. (Courtesy of J. Curley.)

LEGENDARY LOCALS
—— OF ——

SALEM

MASSACHUSETTS

JEROME M. CURLEY, DOROTHY V. MALCOLM,
AND NELSON L. DIONNE

LEGENDARY
LOCALS

Legendary Locals is an imprint of Arcadia Publishing
Charleston, South Carolina

Printed in the United States of America

Library of Congress Control Number: 2013930059

For all general information, please contact Arcadia Publishing:
Telephone 843-853-2070
Fax 843-853-0044
E-mail sales@arcadiapublishing.com
For customer service and orders:
Toll-Free 1-888-313-2665

Visit us on the Internet at www.arcadiapublishing.com

Dedication
This book is dedicated to our legendary locals, those included here as well as the many others who are not listed. Through their efforts, they have made Salem a better place for us all.
—Jerome Curley

Dedicated to the 20 martyrs of the 1692 Salem Witchcraft Trials.
—Dorothy Malcolm

Dedicated to the people in Salem in the past and present who make it such a special place. I say thank you. To my wife, Jane, and my forbears, I also say thank you.
—Nelson Dionne

On the Front Cover: Clockwise from top left:
Brunonia Barry, author (Courtesy of Tattered Cover Bookshop, page 49); William Koen, movie theater owner (Courtesy of Koen Collection, page 100); Laurie Cabot, official Witch of Salem (Courtesy of John Andrews, page 65); Bertini's Restaurant (Courtesy of D.V. Malcolm, page 93); Louis Trudel, hockey player (Courtesy of Paul Plecinoga, Salem Archives, page 115); H&H Propeller (Courtesy of John Pelletier, page 98); Lady Gigi, activist (Courtesy of Gary Gill, page 70); Nathaniel Hawthorne, author (Courtesy of Library of Congress Prints & Photographs Division, page 43); Pep Cornacchio, sportsman (Courtesy of the Cornacchio family, page 116).

On the Back Cover: From left to right:
Waters & Brown wagon (Courtesy of the Clarke family, page 92); Jim McAllister, historian and guide (Courtesy of Jim McAllister, page 68).

CONTENTS

ACKNOWLEDGMENTS

Where do we begin to say "thank you" to all the individuals who assisted us with information, leads, and photographs to create this book on Salem's movers and shakers, past and present? I just hope no one has been left off of this list of kindhearted, generous souls of Salem.

The patience and cooperation of photographer John Andrews of Social Palates has been phenomenal—thank you, John. Paul Plecinoga of Salem Archives has been invaluable in getting photographs to us, especially of sports figures—thank you, Paul. Salem historian, author, and architect John Goff has helped in so many undocumented ways—thank you, John. The Akatyszewski family of Ziggy's Donuts gave me several leads—thank you, Alice and Patty. Author and historian Jim McAllister dug up historical anecdotes on Salem characters, and the Cornacchio family kindly shared Pep with all of us. To Leo Jodoin of Salem Access Television, author Bonnie Hurd-Smith, Sarah Maurno, and Roberta Chadis—thank you, all of you, for your leads, enthusiasm, and support. Author Margaret Press generously gave of her time, allowing me to examine her book and data on the Tom Maimoni case and trial—thank you, Margaret. And finally, to my daughter Cynthia Malcolm Fisher, my cheerleader, for her steadfast support and encouragement of everything I do.

A special thank-you goes to Kirk Williamson, for sharing historical photographs as well as his photojournalism expertise. George Mechling of K&G Enterprises went above and beyond in sharing his John Rogers expertise and photographs, and it is truly appreciated. Dave Joswick of the Great Locomotive Chase website was a great help with photographs and information on Robert Buffum. J. "Cat" Griffith from Vista, California, came through with photographs when no one else could. Judy Fox graciously put together photographs and information on her client, Al Ruscio, for our use. Tony Hyde of the Chicago Bulls organization was very responsive and helpful, as was Mark Steinman of the Pro-Am Pinball Association.

On a more local level, I'd like to thank the staff of the Salem Library. Mike Sosnowski offered suggestions and support, and Theresa Miaskiewicz and the Ayube family graciously shared their heartfelt loss of loved ones in war. This book wouldn't have seen the light of day without these and others, too numerous to list, helping us on this journey of discovery.

We'd be remiss here if we did not thank Erin Vosgien, our editor at Arcadia, for helping us navigate the demands of such a book. Thank you Erin. You've been great.

Thank you all!

Unless otherwise noted, all photographs used in the book are the work of the authors, Dorothy Malcolm, Jerome Curley, and Nelson Dionne. Photographs provided by the Library of Congress, Prints & Photographs Division, are listed as (LOCPPD).

INTRODUCTION

In putting together a Legendary Locals book for a city such as Salem, the challenge is not so much identifying special residents, but choosing from such a rich history and contemporary culture. Unfortunately, given the limits involved, we could not include everyone. We therefore had to choose those people who represented different eras in Salem's history. The selection was further complicated by the lack of usable photographs and information on certain people. Some, in keeping with their unsung hero status, insisted on not being listed; others simply never returned phone calls and e-mails.

Some figures touch a community at various times, then fade into the background, leaving memories and little else. If these people are not highlighted in news sources or history books, recognition of their impact is lost to future generations, while what they did, or started to do, continues to color the tapestry of the city or town.

This project, while highlighting those figures who stand out in our shared history, also looks beyond them, to those other, lesser-known people who have also impacted our lives and our city. While we may not be able to delve deeply enough into history to identify those special people known only through family legends, we are able to see current legends and, by highlighting them, showcase their impact. This book, sitting on a library shelf years from now, will serve as a time capsule of recent Salemites and their impact on us now.

In the years before the town of Naumkeag was founded, this area was in the possession of the Native American Naumkeag tribe. These farming and fishing people had a large settlement along the banks of the Naumkeag River, now called the North River. The area of their settlement corresponds to today's North, Osborne, and Mason Streets in North Salem. In addition to this settlement, there were others scattered throughout the area, including Winter Island, Castle Hill, and the Forest River area.

A decade before the European settlers arrived, a devastating epidemic decimated the Naumkeag people, killing more than two thirds of them. Farms and settlements were abandoned, and survivors lived in fear not only of further illness, but of invasions by warlike northern tribes who sought to take over the lands.

When a small group of Puritan settlers, led by Gov. Roger Conant, arrived in Naumkeag in 1626 from a failed fishing colony in Gloucester, the natives welcomed them. After a difficult year of sickness and misery, the small settlement was supplemented with the arrival in 1628 of more settlers, doubling the population. This influx was led by John Endecott, newly named governor by the Company of the Massachusetts Bay, which had purchased the Dorchester Company.

The arrival of the new settlers and a new governor was not well received by the earlier residents, who referred to themselves as Planters, after their Naumkeag plantation. This led to a number of ongoing conflicts that were finally settled at a convention. A major issue was the cultivation and use of tobacco; the Planters espoused the industry, but the new settlers felt it was evil. An agreement was reached through the work of Roger Conant and John Endecott. Because of this accord, the name of Naumkeag was changed to Salem, a derivative of the Hebrew name Jerusalem ("peace"), based on Psalm 70.

In 1630, after being granted a royal charter, the Massachusetts Bay Company determined to move most governing duties to the colony, along with several hundred new settlers. The company then appointed a third governor, John Winthrop, to take charge of the colony. He arrived in Salem in 1630, heading a fleet of 12 ships full of settlers and supplies. Due to heavy weather, the fleet was separated and staggered into the ports of Salem and Charlestown over several weeks.

Shortly after his arrival, Governor Winthrop determined that Salem was not large enough for the new settlers. He decided to move the seat of government from Salem to a new settlement at Charlestown.

After a brief time there, the government was moved to the Shawmut Peninsula, which was eventually renamed Boston. Salem's brief tenure as the capital of the colony was over. But the town continued to grow and prosper, especially with its seafaring economy.

Settlers came to this Puritan enclave, where planting, fishing, and trapping were mainstays. By 1638, shipbuilding along Salem Neck and the North River had started. It was during this period that Salem's Puritan "legends," such as Winthrop, Sewell, and Hathorne, sought to shape the character and future of the town by rigid adherence to Puritan beliefs.

Into this successful settlement came the dark clouds of fear and distrust with the witchcraft hysteria of 1692. The four-month period of trials had a profound effect on Salem, marking it as the "Witch City." More than 100 people were accused of being witches or wizards. By the time the hysteria waned and clearer heads prevailed, 20 people had been executed. No matter how many apologies or reparations were made, Salem has been forever branded by this experience.

As the settlement grew, trade and shipbuilding expanded. With growth, Puritanism gradually faded as the predominate religion. Salem by the early 1700s was crowded with wharves and shipyards. Like the other colonies, Salem chaffed at the way London ruled the colonies, imposing restrictions and taxes.

There was regular trade between the colonies, England, and the West Indies. As the Salem fleet grew, it was aided by the opportunity presented when England was at war with her European neighbors. Salem merchant traders became privateers; armed with Letters of Marque, they seized enemy ships and their cargoes as spoils of war, increasing Salem's wealth. Merchant traders such as Derby, Crowninshield, and Gray became living legends through their bold actions.

In the years preceding the Declaration of Independence, Salem patriots refused to import tea and other taxed goods. The leaders of the impending American Revolution were frequent visitors, gaining support and encouragement from Salemites. The First Provisional Congress was formed in Salem in defiance of the British government. It was also here that the first armed resistance to British rule took place, in what is known as Leslie's Retreat. Almost two months before Lexington and Concord, armed colonists led by Timothy Pickering, Thomas Mason, and John Felt demonstrated that the line of tolerance for British meddling was fast approaching.

During the Revolutionary War, in addition to sending men to fight, Salem did what it did best: privateering. Throughout the war, Salem privateers seized hundreds of tons of British ships and cargos.

Upon independence from Great Britain, Salem merchants turned their sights to the sea, beginning the golden age of Salem trading. Merchant fleets were scattered across the seas in search of trade. They were the first to trade with Japan and the Far East, bringing back spices, silks, and curiosities. Vast fortunes were made and, from such wealth, mansions and public buildings sprang up throughout Salem. It was an era of Salem royalty, with its merchant princes leading the way.

At the height of East India trade, Salem had 50 wharves throughout the city. On any day, the skyline was crowded with masts and flags of countries from around the world. There were wharves along Front Street, Norman Street, and the coast, as well as on the North River to present-day Grove Street.

Wealthy captains and merchants had large, elegant homes built along Chestnut and Essex Streets. They started charities, libraries, and the oldest continually operating museum in the country. Many of these buildings remain as testaments to not only these merchants' ingenuity and craftsmanship, but also to the foresight of those who preserved this great heritage.

It was during this time that Salem's most famous literary figure was born. Nathaniel Hawthorne, the writer of such classics as *The Scarlet Letter* and *The House of the Seven Gables*, was born on Herbert Street in 1804. His writings have forever stamped his vision of Puritan days and Salem on the imagination of the country. The 19th century saw Salem embrace the lyceum movement, which brought literature and science to the forefront. Salemites were given the opportunity to hear people who would change the world through their literary, scientific, and philosophical expertise.

However, Salem's trading days were numbered, due to a variety of factors, both political and natural. Its trade shifted from exotic goods to coal, needed to fuel the growing factories and mills in Essex County. Areas that used to be dedicated to shipyards and ropewalks suddenly were dotted with leather factories and mills.

Salem became a hub for manufacturing in the middle to late 1800s, with such companies as the Naumkeag Steam Cotton Mill and Hygrade Sylvania Lamp, as well as numerous tanneries and factories. Immigrants from around the world were drawn to Salem.

With its jobs, large shopping district, and amusements, Salem continued to be a vital center of commerce for the region. The town went from a dour amusement-barren landscape to a center of entertainment with its theaters, vaudeville palaces, and the Willows. These became the place that spawned new legends. During this industrialization of America, legends such as Alexander Graham Bell, John Dixon, and Moses Farmer made advances that would forever change the face of the nation.

This growth was marred by a devastating fire in 1914 that destroyed 1,376 buildings on 253 acres—one third of the city. While much history was lost, much was also spared, leaving Salem with an intact architectural history. Bowed but not broken, Salem and its immigrant population almost immediately rebuilt some fine examples of early-20th-century architecture.

As time passed, more expansion occurred, wharves were removed, rivers were channeled into canals or diverted, and land was added. Salem undertook major redesigns early in the 20th century, such as the depot removal and railroad-crossing improvements. Such time-consuming and disruptive projects took their toll on downtown businesses. It was not long before shopping malls appeared; one very close to Salem opened in 1958. This marked the beginning of a low point for Salem. Stores moved to malls and the Naumkeag Mill closed in 1954 in search of cheaper labor. In the 1960s and 1970s, Salem found itself a victim of corporate mergers; its industries were suddenly being acquired by foreign companies and closing up or moving.

In this era of decline and self-examination, Salem began to market itself as a tourist attraction. Rather than downplaying the terrible witch history, the city embraced it, drawing thousands each October for Haunted Happenings. This has spawned a cottage industry of witchcraft shops, psychic readers, and specialty museums.

Over time, Salem has sought a balance by encouraging examination of its historic character, its many architectural treasures, and its maritime and literary history. These efforts have been greatly aided by the merger of the Peabody Museum with the Essex Institute, resulting in a major expansion of this world-class museum. Tourism draws over a million people a year and has resulted in a renewed interest in Salem's history, far beyond witchcraft. It is hoped that this will spur preservation efforts in the run-up to Salem's 400th anniversary.

Throughout Salem's history, from times of high-flying commerce and conspicuous wealth, to periods of severe economic depression and unemployment, there have been a few constants: dedication to public service, art, and literature.

Each age spawns new legends who think beyond themselves to the greater good. Sometimes, they are wealthy citizens willing to give; other times, they are ordinary citizens who see a need for a solution and go about supplying it. Along with this spirit of Salem, we've been blessed with a rich artistic and

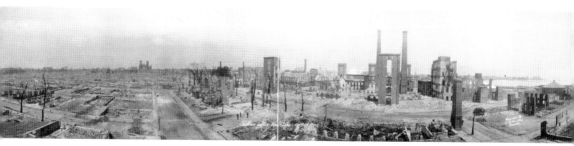

1914 Fire

This panoramic photograph, taken on June 25, 1914, shows the fire's devastating effect. A third of the city burned in the blaze, which was caused by an explosion in a leather factory. (Photograph by C.H. Phinney; courtesy of LOCPPD.)

literary history that captures the vision of each age. Whether it is Hawthorne's *Young Goodman Brown*, Chris Dowgin's whimsical drawings, or Robert Booth's *Death of An Empire*, they are uniquely, wholly Salem. These artists, along with all Salem legends, help us understand what it is to be a Salemite in the past, present, and future.

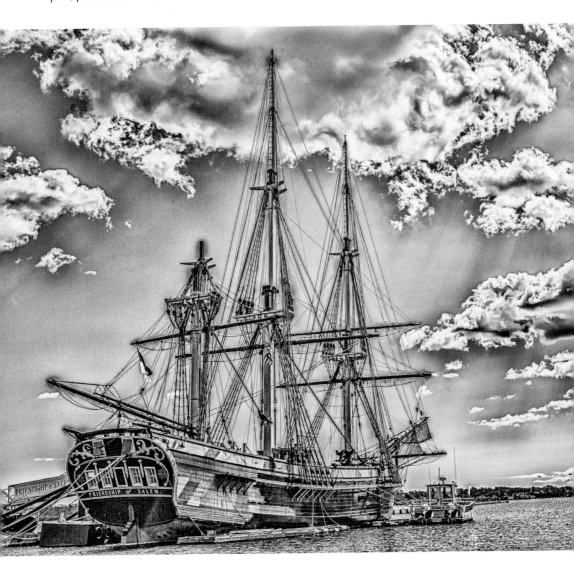

Friendship
This ship is a 171-foot replica of a 1797 East Indiaman ship. *Friendship*, built for the National Park Service, is both a museum and a Coast Guard–certified vessel. The original was built by Enos Biggs. Photographer John Andrews of Social Palates captured this innovative view of the oft-photographed vessel in 2000. (Courtesy of John Andrews.)

CHAPTER ONE

History

A people without the knowledge of their past history, origin and culture is like a tree without roots.

—Marcus Garvey

Salem can be looked at as a living library and museum. So much of its history surrounds us every day, offering us a sense of place. Past generations kept Salem's legacy alive, even during difficult times. They knew who they were and sought to keep ties with earlier residents through preservation. From its earliest days, Salemites had a sense of history in what they were doing. Whether it was the brief notes of Roger Conant, the records of the early Commoners, or the diaries of Bentley, Holyoke, Fabens, and others, Salemites recorded both the important and the trivial in order to give later residents a sense of the days they were experiencing.

These resources, sporadic in number and preservation, give us glimpses of Salem both strange and familiar. Reading the accounts, we smell the tar and brine of early shipbuilding. We witness arguments over the direction of Salem and the country, including such topics as the new constitution, the embargo of 1812, abolition, immigration, war, or local elections.

The tapestry of history is woven throughout Salem writings. The people featured in this chapter speak to us across the years. Encountering them, we see the evolution of Salem from a small village to the city it is today. We see the shifts from a fishing village to a maritime trading center, to industrial center, to empty factories and broken promises, to renewal and a tourist economy.

Salem never stands still, but continues to adapt to new realities, using its history as a compass for the future. Today, Salem is home to a world-class museum, innumerable historic properties, a vibrant university, and thriving commerce. Salem is a restaurant destination and home to the annual month-long Haunted Happenings.

Amid the highs and lows of history, Salemites of every generation continue to stand with the craggy-faced Roger Conant, staff in hand, looking into the wind to a better future.

Roger Conant (1592–1679)
This iconic statue depicts Salem's founder, Roger Conant, standing on a rocky windswept shore. The statue of the Salem leader, by noted sculptor Henry Hudson Kitson, embodies Conant's stalwart leadership amid the winds of change. Due to its proximity to the Salem Witch Museum, this statue is often mistakenly thought to portray a witch.

Conant immigrated to Plymouth in 1623 with his wife and son. He stayed there for a year and then moved to Nantasket to flee the religious strictness of the Separatists who ran the colony. He was of the opinion that the religion he professed in England should be purified, not replaced, by what he and others considered a stricter, intolerant faith. After an argumentative year, this group of "Puritans" moved south to Nantasket, where they could pursue the act of purifying their faith. In 1625, the Nantasket group moved back north to Cape Ann and founded a farming, fishing, and trading colony. Conant was asked by the Dorchester Company to be governor at Gloucester. It quickly became apparent that this settlement was doomed to failure. While some chose to return to England, many of the 25 settlers agreed to follow Conant rather than the minister, Lyford, who wanted to move south to Virginia.

In 1626, Conant was given permission by the Dorchester Company to move the settlement up the coast to the mouth of the Naumkeag River. After two years as leader of the colony, Conant was replaced by Gov. John Endecott, who was appointed by the Dorchester Company.

In 1629, amid much resentment and consternation between the new and old settlers, a convention was held. Out of that convention, a modicum of harmony was restored, thanks to Conant and Endicott. To highlight this new state of affairs, the town's name was changed from Naumkeag to Salem, taken from the Hebrew word for peace. Conant, amid many personal tragedies, dedicated himself to fostering the settlement of Salem. He laid out the boundaries for a number of towns in the area as they were broken off from the initial large area of Salem.

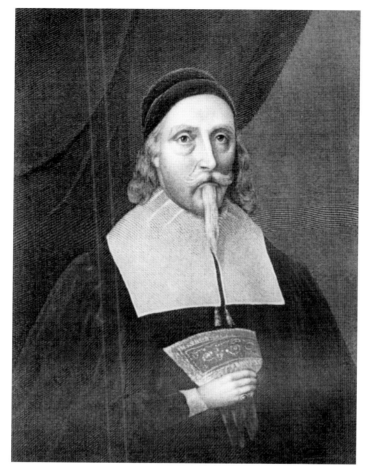

John Endecott (1588–1665)

John Endecott was chosen governor of the Massachusetts Bay Colony when the Dorchester Company was purchased. The colony had been able to secure a charter from King Charles I granting this company the land from three miles south of the Charles River to three miles north of the Merrimack River.

Endecott led a group of 60 settlers to Naumkeag in 1629 and presented himself as governor of the new colony. Roger Conant, the de facto governor of the now defunct Dorchester Company, agreed to Endecott's leadership. While there was some friction between the old and new settlers, those issues were worked out in a general meeting. In honor of this peaceful transition, they renamed Naumkeag ("fishing place") Salem, meaning "peace."

John Endecott's rule was considered fair but strict by the colonists who conformed to Puritan ways. However, he was far less tolerant of those who were not religious or who chose not to follow the Puritan traditions. This was especially true for Quakers, who were persecuted and banished. His rule gained the colony a reputation as a Puritan establishment where English dissidents could find relief.

When he arrived in Salem in 1629, he planted a pear tree he had brought with him on the ship *Arbella*. It is believed he transplanted the tree to his farm in what is now Danvers sometime between 1632 and 1649. To this day, that tree still bears fruit and is believed to be the oldest living cultivated fruit tree in America. In the early 1800s, Reverend Bentley obtained twigs from the tree and passed them on to Pres. John Adams, who in turn cultivated them.

When John Endecott was replaced as governor by John Winthrop, he took on a variety of roles in colonial government. He also served again as governor in 1644–1649, 1651–1655, and, finally, in 1675.

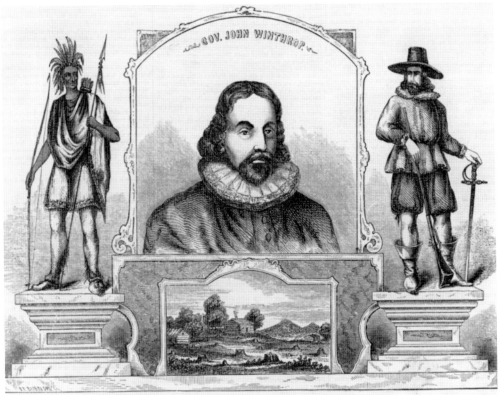

IN HONOR OF THE BIRTHDAY OF GOVERNOR JOHN WINTHROP, BORN JUNE 12, 1587.

John Winthrop (1587–1649)

In 1630, there was a resurgence of fear of persecution among Puritans in England after King Charles I dissolved Parliament. Siding with the Church of England, the king had little tolerance for Puritans. Many Puritans of wealth and means felt it was time to leave England. Rather than keep the colony rule in England, the Massachusetts Bay Company was reorganized, sending the ruling authority to the colony for self-rule. The company then chose John Winthrop as the new governor to replace Endecott. Winthrop was a wealthy lawyer who had just lost his lucrative post in the Court of Wards and Liveries because he was a Puritan. He was well known to the leaders of the Massachusetts Bay Company, who felt he was a good choice as a religious and administrative leader.

The new governor, in possession of a new charter, led a fleet of 12 ships that landed in Salem in 1630 with 1,000 additional settlers. Many of these new colonists were looking for the freedom to practice their Puritan faith. This was part of the Great Migration from England.

While he was authoritarian, he was also moderate in that he opposed the more conservative vice governor, Thomas Dudley, as well as the liberal theologian, Rev. Roger Williams, who was banished from Salem and went on to found Providence, Rhode Island.

Winthrop served as governor for 12 of the first 20 years of the Massachusetts Bay Colony. He was known as a religious person who saw the potential of the colony. While still on board his flagship, *Arbella*, he gave a sermon in preparation of landing in which he envisioned the new plantation as a "City on a Hill" that would be a beacon to all, showing the favor God bestowed on them as his true followers. This sermon, with its imagery drawn from the Old Testament, has been a theme of later presidents, especially John Kennedy and Ronald Reagan, whose speeches about America as a "City on a Hill" championed the exceptionalism of the American people. (Courtesy of Library of Congress.)

Judge Samuel Sewall (1652–1730)

Samuel Sewall was the only judge of Salem's witchcraft trials to ever publicly apologize for his role in the debacle of 1692. While others apologized in private or excused themselves, saying it was the work of the devil, Judge Sewall humbled himself, in public, in recognition of how reprehensible his role was in colluding with the other judges in putting 20 people to death. In January 1696, the apology he wrote to the public was recited aloud in church by the pastor. Judge Sewell stood up, head downcast, hearing his written words spoken to the congregation. What makes his apology so poignant is that, in an age when the English class system was still so acutely pronounced and inherent, Judge Sewall was one of the most important men in Massachusetts Bay, a magistrate of the Superior Court of Judicature and one of the wealthiest men in the region. It was a monumental, albeit justified, comedown. In part, he wrote: "Samuel Sewall, sensible of the reiterated strokes of God upon himself and family . . . Desires to take the Blame & Shame of it, Asking pardon of Men, and especially desiring prayers that God who has an Unlimited Authority, would pardon that Sin."

A fundamentally decent man, Judge Sewall was also repulsed by the slave trade from Africa. In this excerpt from his essay of 1700 on slavery, *The Selling of Joseph, A Memorial*, he writes:

> It is likewise most lamentable to think, how in taking Negros out of Africa, and selling of them here . . . Men from their Country, Husbands from their Wives, Parents from their Children. How horrible is the Uncleanness, Mortality, if not Murder, that the Ships are guilty of that bring great Crouds of these miserable Men, and Women. . . . O Tis pity there should be more Caution used in buying a Horse, or a little lifeless dust; than there is in purchasing Men and Women: When as they are the Offspring of GOD, and their Liberty is . . . Auro pretiosior Omni [Liberty is more precious than all the gold in the world]. This Law being of Everlasting Equity, wherein Man Stealing is ranked amongst the most atrocious of Capital Crimes: What louder Cry can there be made of the Celebrated Warning, Caveat Emptor. (Courtesy of LOCPPD.)

Witchcraft Memorial, 1992

In 1692, fed by medieval beliefs, Salem experienced a witchcraft hysteria that has forever altered the perception of the city. During its course, hundreds were accused of being in concert with the devil and threatening the very nature of the colony. Acting on this clear and present danger, leaders imprisoned and tried their neighbors, based on wildly improbable testimony fed by fear and ignorance. When the hysteria came to an end, 20 people had been executed as witches. Soon thereafter, Salem was shamed by reflection on what it had done. The shame lasted for centuries.

While people had forever paired witchcraft with Salem, the town wanted to forget this history that reflected so badly on the early colony. For many years, Salem sought to downplay this incident and concentrate on its later history. This never was completely successful, as historical and literary accounts continued to capture the public's imagination. After hundreds of years of trying to ignore this history, the city and merchants embraced it in the 1970s, when Salem's industrial base was waning. Since then, Salem has become a major tourist attraction, its crowning achievement being the annual Haunted Happenings.

In an effort to give context to the hysteria and highlight the need for tolerance, in 1992, Salem created an enduring tribute to the victims. The keynote speaker at the memorial's opening was the Nobel laureate Elie Wiesel. The Salem Witch Trials Memorial, with its concrete benches inscribed with the names of the victims, has been acclaimed for its power and simplicity. Six million people have visited this site since its establishment. Over time, the memorial required repairs and renewal. When refurbished in September 2012, a 20th-anniversary rededication took place. Descendants of the victims participated in remembering the cost of intolerance. In addition to the memorial, there is an annual Salem Award given to champions of human rights and social justice.

The victims in 1692 were Bridget Bishop, George Burroughs, Sarah Good, Elizabeth Howe, Susannah Martin, Rebecca Nurse, Sarah Wildes, Martha Carrier, George Jacobs, John Proctor, John Willard, Giles Corey, Martha Corey, Mary Easty, Alice Parker, Mary Parker, Ann Pudeator, Margaret Scott, Wilmot Redd, and Samuel Wardwell.

Elias Hasket Derby (1739–1799)

Derby is often cited as America's first millionaire. As a teenager, he went to work for his father, Capt. Richard Derby, a sea merchant with ships trading in the West Indies and the South Atlantic. Young Elias managed the business from Salem and never went to sea, as his bothers had. He greatly expanded this sea trade and acquired 13 vessels by 1760.

Derby's family supported the American Revolution, and his sailors became privateers feasting on English shipping. At the same time, Derby invested in a number of Salem privateers, who also seized enemy ships. When captured ships were sold, he reaped enough benefits to continue his expansion. Building bigger and better ships, he sent out more than half of the 158 privateers from the Port of Salem. By the end of the war, Derby had a fleet of former privateers in search of trade.

Armed with little more than a hunch, he sent the ship *Grand Turk* to the Orient, opening trade there. It was the first ship to call at Mauritius, Calcutta, and the third ship to arrive in China. His ships successfully sailed the seas in search of trade, making him a "merchant prince" of Salem. His ships, as well as others he invested in, had regular trade with the East and West Indies, Cape of Good Hope, Sumatra, India, Russia, and Europe. While he traded in virtually any saleable commodity, he steadfastly refused to be involved in the slave trade, which was making some New England captains wealthy. He stated that "He would rather sink the whole capital employed than directly or indirectly be concerned in so infamous a trade."

In 14 years, the Derby ships made 125 voyages to Europe and Far East ports. Out of 35 vessels, only one was lost at sea. The success of Derby and fellow merchants transformed the face of Salem from a small fishing town to one of the wealthiest ports in America. So powerful was the community that residents of the Far East thought Salem was a country. The trade's success initiated a building boom of homes and mansions for merchants and sea captains. Many of these buildings still stand, making Salem an architectural treasure trove of the Federalist period. Derby Wharf and the Derby House are part of the Salem Maritime National Historic Site, the oldest national historic site in the United States.

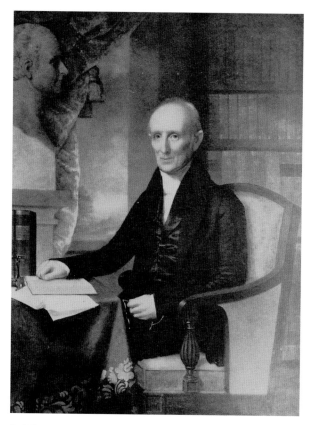

Nathaniel Bowditch (1773–1838)

Born into poverty, Nathaniel, the fourth of seven children, left school at the age of 10 to work with his father as a cooper. While these circumstances might have ended all hope of education in others, to young Nathaniel, it was the beginning of his lifelong self-education. Failing at the cooperage, he was placed as a clerk with a ship's chandler. At the same time, he continued his dedication to learning. He was taught navigation by an old sailor, learned surveying at 14, and assisted in the town survey. He taught himself foreign languages so he could study a variety of works. This brilliant young clerk soon came to the notice of the most learned men in Salem, who arranged for him access to the best scientific books of the day. By his late teens, Bowditch was considered an outstanding mathematician with few, if any, peers. At 21, he signed on as captain's writer and second mate on a yearlong voyage to the Indian Ocean. During this and subsequent voyages, he studied navigation, correcting many mistakes in the existing navigation books. Upon his return to Salem, Bowditch was asked to help revise new editions of the books. After two revisions, the publisher felt that the *American Practical Navigator Book* should be published under his name with his new approaches incorporated.

In 1802, the book was published, revolutionizing navigation and making sailing much safer. The book has been continuously in print; almost a million copies have been printed. It is on every US Navy ship to this very day and is the core of most ships' libraries. Harvard College honored Bowditch with a master of arts degree shortly after the book's publication. This was the first of many honors Nathaniel Bowditch received throughout his lifetime.

After being at sea as an officer and captain, Bowditch retired at age 30. He was soon named president of the Salem Fire & Marine Insurance Company, where he remained for 20 years. During this time, he continually revised his book and started his lifelong task of translating Laplace's *Mecanique Celeste*, a compendium of all known information about the heavens. His translations made this field accessible to English-speaking scientists. He finished three of the four volumes before his death in 1838.

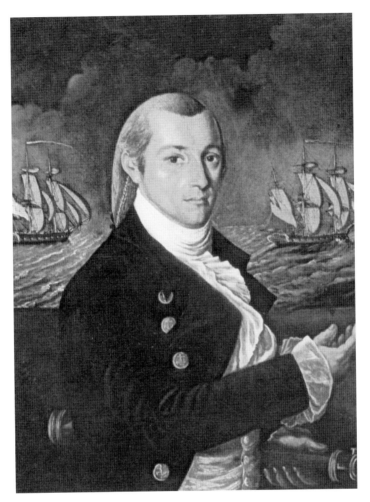

Capt. Jonathan Carnes (1756–1827)

A former privateer turned merchant-captain, Jonathan Carnes was trading at the port of Bencoolen in Sumatra (Indonesia) in 1794 when he learned that pepper, a valued spice, was available at the port of Padang farther up the coast of Sumatra. Traveling in poorly charted, reef-strewn waters, his ship made port at Padang only to learn there was little pepper there. While filling his cargo hold with coffee, spices, and some pepper, he learned that quantities of pepper might be possible farther north in the unknown, uncharted waters of northwest Sumatra. Returning to Salem on his ship, *Grand Sachem*, Carnes's cargo was lost on the reefs of Bermuda. This did not deter his conviction that he could find the source for the pepper trade. At Salem, he convinced Jonathan Peele, his uncle, to fund a new expedition.

In 1798, the brigantine *Rajah* cleared Salem with a crew of 10 men and four cannons for their secret destination. After sailing the treacherous coast, Carnes was able to find the highly coveted pepper source and trade with the natives. After waiting for a second crop, the *Rajah* reentered the Port of Salem with 158,500 pounds of pepper, ushering in an age when Salem controlled the world's pepper trade.

Carnes also brought home a number of natural and manmade specimens that became the first donations to the new East India Marine Society, later the Peabody Essex Museum. He was able to make several more secret trips before other merchants discovered his source and were able to compete. This pepper trade ushered in a time of unprecedented growth and wealth in both the East India trade and the town of Salem. The wealth generated and fueled both building and philanthropy by Salem's sea captains and merchants.

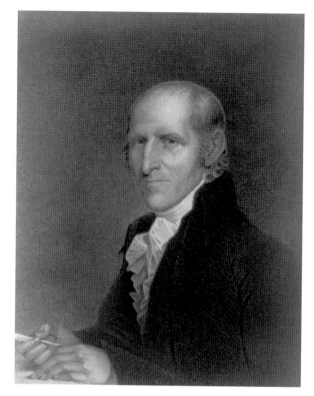

Timothy Pickering (1745–1829)

Pickering is considered the most famous of the members of a distinguished family that came to Salem in 1630. He was born in what is considered the oldest house in America, continuously occupied by one family for 10 generations until the 1990s, when it became the Pickering Foundation. A 12th-generation Pickering was married there in 2011.

Timothy graduated from Harvard in 1763 and went on to practice law in Salem while holding various civic posts. A colonel in the Salem Militia, he was involved in the confrontation at Salem's North Bridge in February 1775, known as Leslie's Retreat, when Salem's townspeople stopped British troops in their search for cannons. Pickering was a member of the Revolutionary Committee of Correspondence and Safety. He entered the Continental Army as a colonel and fought at Brandywine and Germantown. He was also at Cornwallis's surrender at Yorktown.

After occupying a number of special positions for the new government, George Washington appointed Pickering postmaster general in 1791. He went on to serve as secretary of war in 1795 and secretary of state in both the Washington and Adams administrations, from 1795 to 1800, making him the only person to hold three cabinet positions. As secretary of state, he strongly supported closer relations with England. This advocacy at the expense of making peace with France led to his dismissal by Pres. John Adams.

He returned to Salem in 1802, when he was appointed chief justice in the Court of Common Pleas. In 1803, he was elected to the Senate as a member of the Federalist Party, where he served until 1811. He was very much opposed to the War of 1812 and its devastating impact on New England states caused by the embargo. Many in New England felt they should remain neutral in this war. This lack of support for the Federalist viewpoint led Pickering to champion the secession of the New England states from the United States at the Hartford Convention in 1814–1815.

From 1813 to 1817, he served as a congressman and, in 1820, returned to Salem. He then ran unsuccessfully for Congress in 1820 and lived at the family farm on Broad Street until he died there in 1829. He is buried in the Broad Street Cemetery across the street from his house. His ancestral home is open to visitors on a regular basis. (Courtesy of LOCPPD.)

**Dr. Edward A. Holyoke
(1728–1829)**
Following his graduation from Harvard in 1746, Holyoke studied medicine and began his lifelong practice in Salem. Dr. Holyoke received Harvard's first medical degree. Throughout his life, in addition to his pioneering work in vaccinations, he maintained enlightening diaries. He was a founder of the Massachusetts Medical Society and the American Academy of Arts and Sciences. He helped start the Salem Athenaeum and the Essex Historical Society.

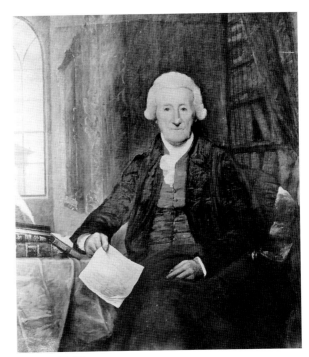

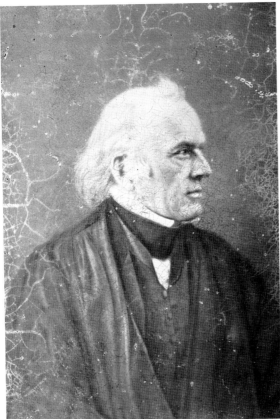

Joseph Story (1779–1845)
Story graduated from Harvard in 1798 and practiced in Salem in 1801. He was a state representative and congressman and, in 1811, became the youngest associate justice of the Supreme Court. His three-volume *Commentaries on the Constitution* is a cornerstone of jurisprudence. His best-known decision was in the *Amistad* case, which declared rebellious slaves free. The case was dramatized in the 1997 movie of the same name. (Courtesy of LOCPPD.)

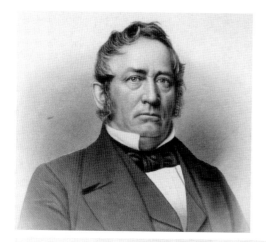

Stephen Clarendon Phillips (1801–1857)
Anticipating the end of the East India trade, Phillips turned to railroads and coal to feed the new mills of industrial New England. His work kept Salem a commercial hub, as its wharfs were refurbished for the coal trade. Phillips served as a state representative, senator, congressman, and mayor. He was a philanthropist, especially for education, donating his salary as mayor to the education of Salem children.

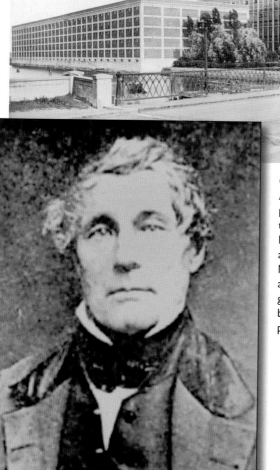

Capt. Nathaniel Griffin (1797–1876)
At the age of 17, Griffin shipped out on a privateer; by 24, he was a captain, sailing to the East Indies, Europe, South America, and Russia. In 1835, Griffin retired and opened a ship's chandlery. He was treasurer for the Naumkeag Steam Cotton Company and almost single-handedly raised the capital to get the mill, shown above, up and running by 1847. It was the first and largest steam-powered mill, employing 600 people.

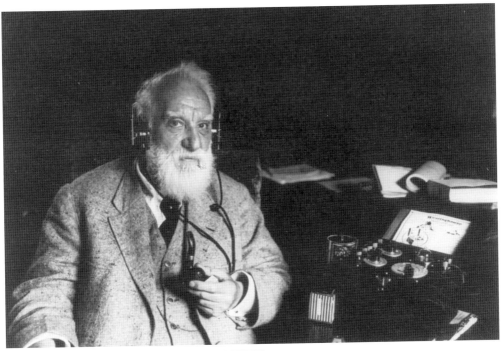

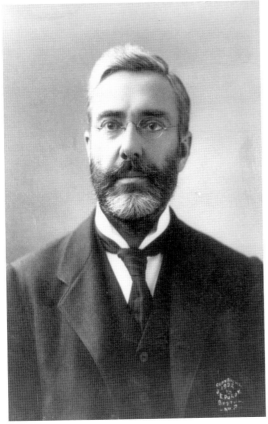

Alexander Graham Bell (1847–1922)
Bell lived in Salem from 1872 to 1876 while working on the telephone and tutoring the Saunders' deaf grandchild. It was here that Bell improved the telephone for long-distance use. On February 12, 1876, Bell lectured on and demonstrated the first long-distance call, between the Salem Lyceum and his Boston laboratory. In addition to improvements to the telephone, Bell made inventions in fiber optics, hydrofoils, and aeronautics. (Courtesy of LOCPPD.)

Thomas Augustus Watson (1854–1934)
Watson was a Salem native with many talents. He worked with Bell on the telephone design for five years. At age 27, the wealthy Watson pursued other interests. He founded the Fore River shipyard in 1883, studied geology, then assayed ore deposits in California and Alaska. He then turned to acting, writing and performing in plays. Watson lectured on geology, the telephone, and acting until his death. (Courtesy of LOCPPD.)

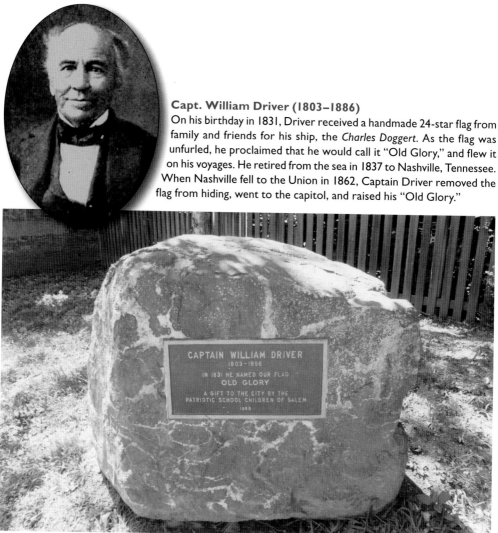

Capt. William Driver (1803–1886)

On his birthday in 1831, Driver received a handmade 24-star flag from family and friends for his ship, the *Charles Doggert*. As the flag was unfurled, he proclaimed that he would call it "Old Glory," and flew it on his voyages. He retired from the sea in 1837 to Nashville, Tennessee. When Nashville fell to the Union in 1862, Captain Driver removed the flag from hiding, went to the capitol, and raised his "Old Glory."

John F. Hurley (1844–1935)

Hurley was elected mayor five times between 1901 and 1914. He was Salem's first Irish-born mayor and the only one recalled from office. He sported a tall silk hat that provided him with the nickname "Silk Hat Hurley." Hurley was mayor during the Great Salem Fire. The shortcomings of the police, fire, and municipal services as well as his attempts to "interfere" in the departments were the basis of a recall election. (Courtesy of LOCPPD.)

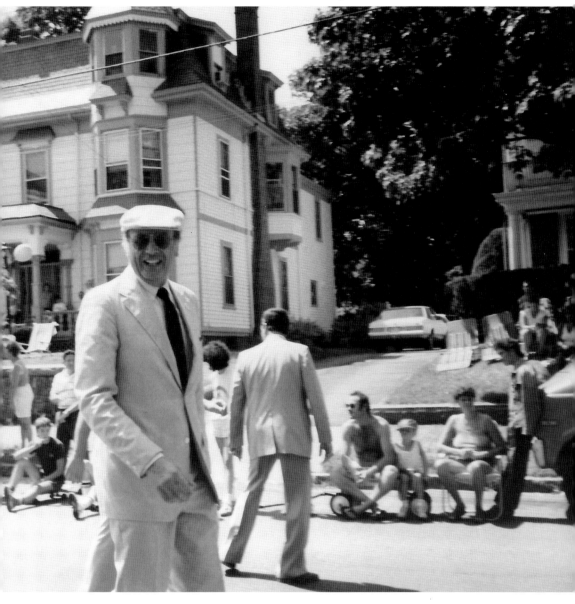

Mayor Sam Zoll (1935–2011)
Zoll gave the city of Salem a lifetime of service. At 23, he was elected to the city council. He served as a state representative for two terms and was mayor of Salem from 1970 to 1973. At this time, the city was rethinking its efforts at urban renewal, which was rapidly eroding the historic nature of Salem. Mayor Zoll agreed with those committed to restoration and renewal and was a leader during the renaissance of the downtown area. When the federal government sought to use Winter Island for storage, he led the efforts for Salem's reclamation of its land. In 1973, he was appointed special justice of the Ipswich District Court. In 1976, he became chief justice of the Massachusetts District Court System, where he stayed until his retirement in 2004. His legacy of community involvement and restoration has had a lasting effect on Salem. (Courtesy of Marjorie Zoll.)

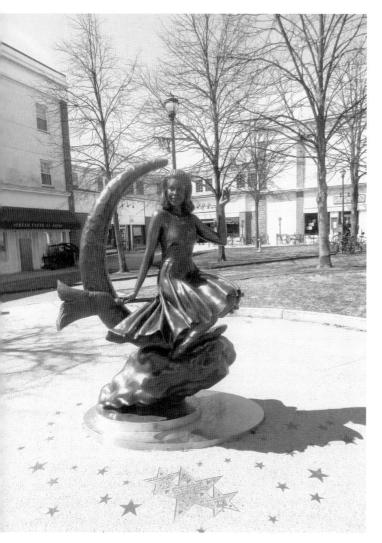

The Samantha Stevens Statue, 2005

The Samantha Stevens statue commemorates the local filming in 1970 of seven episodes of the popular television show *Bewitched*. The statue depicts the show's star, actress Elizabeth Montgomery, based on the show's logo. Amid some controversy, the city accepted the statue from the TV Land network in 2005. It was placed in Lappin Park on Washington Street. Many cast members attended the dedication in June 2005. "Samantha" has become a major tourist attraction.

Mayor Kimberly Driscoll (1967–)

Driscoll is Salem's first female mayor. Born in Hawaii, she graduated from Salem State College with a political science degree. After earning her law degree from Massachusetts School of Law, she worked in real estate law and political affairs. She began her mayoral campaign by going door to door, acquainting herself with Salemites. She won on the Democratic ticket in 2006, and Mayor Driscoll continues serving Salem today. (Courtesy of Mayor Driscoll.)

CHAPTER TWO

Art

Learn the rules like a pro, so you can break them like an artist.

—Pablo Picasso

Salem is a Renaissance city. It hasn't always been so, as the town has experienced its ups and downs, like most regions. But it always manages to reinvent itself. The city currently embraces the arts in all its forms and maintains bonds with artists, patrons, collectors, and followers. Several years ago, Salem's Peabody Essex Museum conducted a mammoth exhibit, Painting Summer in New England. The cover of the catalog was a painting by the great impressionist and Salemite Frank W. Benson. It depicted four pre–World War I ingénues relishing the sunshine and breeze on a hillside, gazing over the ocean to the horizon. It epitomized summer in Salem and idealized the town in a previous era.

Benson was one of America's foremost impressionists and represented Salem as it was. Today, Salem features the art of Racket Shreve, Ellen Hardy, Charles Lang, Henry Zbyszynski, John Hutchinson, and Sheila Farren Billings, among many others. Their works coexist in an often-unpredictable sense, and many are atypical of the work of Benson and artists of earlier generations. Residents can marvel at Samuel McIntyre's architecture of the late 1700s and early 1800s while meandering along Chestnut Street, or admire Sophia Peabody Hawthorne's Italian landscapes in the Peabody Essex Museum; they can also head to Artists' Row and take in the fanciful, childlike art of Chris Dowgin. Farther along Derby Street, in the direction of the Willows, are the eccentric ironwork sculptures of Herb Mackey on Blaney Street.

Today's artists of Salem stay true to themselves, tweak some of the elements of style, and create a world that is not always idealized but, rather, subjective, sometimes startling (this is Salem, after all), and extraordinary in its own way. From the serene maritime art of Racket Shreve to the fantastical themes of Charles Lang, Salem is never, nor ever will be, at a loss for topical, fresh, and inspiring art.

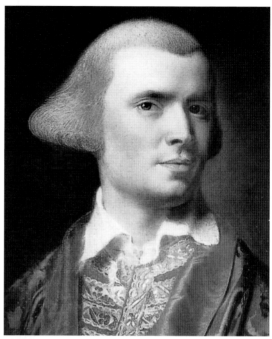

John Singleton Copley (1738–1815)
Copley is considered the greatest Colonial-era painter in America. Born in Boston of impoverished Irish parents, he early on exhibited an amazing talent for art. Self-educated, his insightful portraits as well as his elegant manners made him a favorite of the merchant-class political leaders. While painting Salem's merchant families, he lived in Ruck House on Mill Street for a few years. He moved to London, where his fame continued.

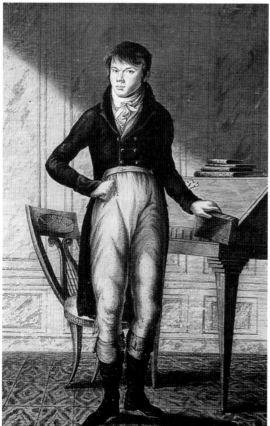

Michel Felice Corné (1752–1845)
Corné fled the Napoleonic wars and arrived in Salem on one of Elias Derby's ships in 1799. He painted for Derby and other wealthy residents, gaining a reputation for marine paintings and murals. After 1822, Corné lived in Newport, Rhode Island, where he produced a number of murals, still preserved in the Sullivan-Dorr House. The New-York Historical Society has given him credit for bringing the "poisonous" tomato to the American table.

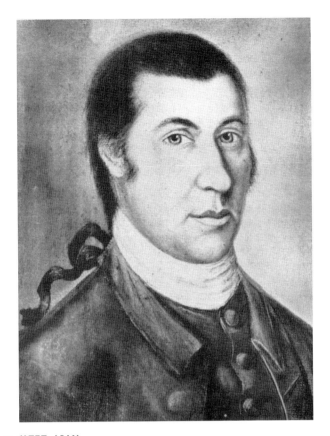

Samuel McIntyre (1757–1811)
The unmatched Architect of Salem has become synonymous with the Federal-style architecture that dominates the historic buildings of Salem. In 1981, a historic district in Salem was named the McIntire District after him (albeit with an alternate spelling), and in 2007, Salem's Peabody Essex Museum hosted an exhibition of McIntyre's woodworking, sculpture, and architecture.

McIntyre, trained as a woodcarver, developed into an architect. Hired by Salem's wealthy merchants, such as Elias Hasket Derby, McIntyre built homes that still stand and that serve as some of the greatest examples of Federalist architecture in the country. Benefiting from McIntyre's skills as a woodcarver, sculptor, and craftsman, these buildings are considered historic treasures and museum pieces. In addition to his elegant designs of buildings, both public and private, McIntyre designed and carved signature woodwork for interiors and exteriors. To this day, these buildings uphold his reputation for excellence. His skill level was such that even now, over 200 years since his death, his work is considered museum quality. This was attested to in 2011, when a world-record auction price for Federal furniture was set at $662,500 for one of McIntyre's mahogany side chairs.

When McIntyre was young, Rev. William Bentley encouraged him to pursue sculpting as well as his love of knowledge in the arts and architecture. McIntyre sculpted a bust of Governor Winthrop and gave it to Bentley. That bust is currently among the holdings of the American Antiquarian Society in Worcester, Massachusetts. McIntyre produced other wood sculptures, his most notable being the large medallion of George Washington that was placed on the arch in Salem Common. He was also justly applauded for his woodcarvings of eagles; a reproduction is housed in the Peabody Essex Museum and another adorns Salem's Old Custom House. Throughout his career, McIntyre received assistance from his family. His brothers, Joseph and Angier, both carpenters and master builders, as well as his son Samuel, and Joseph's son—all accomplished woodcarvers—worked together on most of McIntyre's projects, which unmistakably transformed the face of Salem.

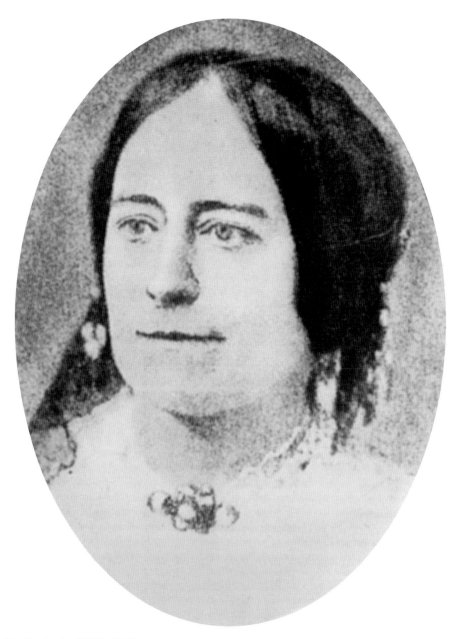

Sophia Peabody (1809–1871)

Peabody is largely known as the wife of Salem's favorite son, Nathaniel Hawthorne. A gifted artist in her own right, she made delicate and charming sketches of her family, landscapes, and surroundings. Her oil paintings, many depicting her beloved Italy, are housed in world-class museums. She also kept thought-provoking journals of everyday life, motherhood, household activities, and being the wife of one of the country's greatest authors. Apart from her talents, not nearly as appreciated or recognized as her husband's or even those of her children, she quietly soldiered on, willingly supporting her melancholy husband and deeply despondent daughter, Una. Sophia Hawthorne was too occupied with a famous husband whom she adored and three dissimilar children to further her own artistic ambitions, distinct as those were.

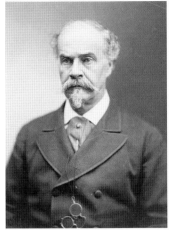

William Wetmore Story (1819–1895)
William Story graduated from Harvard in 1838 and Harvard Law in 1840. He practiced law with his father, Supreme Court Justice Joseph Story. When his father died, he pursued art studies, especially sculpture. In 1850, he moved to Italy, where he developed as an artist and was at the center of the art community in Rome. His works are in several major museums around the world. (Courtesy of LOCPPD.)

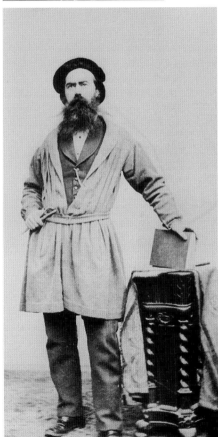

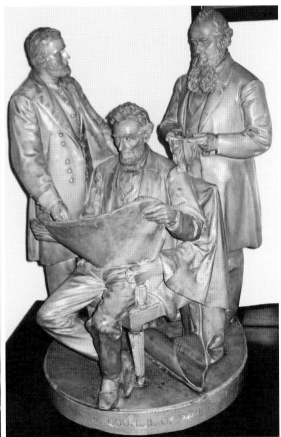

John Rogers (1829–1904)
Born in Salem, Rogers studied fine art in Rome and Paris and returned as a sculptor. From 1859 to 1892, he created low-cost plaster statues. His popularity peaked during the Civil War with his patriotic themes. His affordable works changed the art world, allowing collectors of modest means to appreciate and purchase art. His literary and historical themes are still compelling. (Courtesy of K&G Enterprises, George Mechling.)

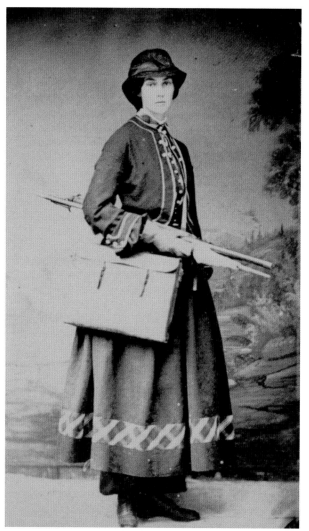

Fidelia Bridges (1834–1923)
Bridges was born in Salem. She moved to New York in her teens and studied art. She was best known for her minute, delicate, and flawless countryside images. Bridges painted nature-inspired watercolors for lithographer Louis Prang, creating Christmas cards from 1880 to 1899. Bridges was the only woman inducted into the American Watercolor Society. The charming bed-and-breakfast adjacent to Salem's Hawthorne Hotel was named for this accomplished artist.

Philip Little (1857–1942)
Little, a fine artist, was sometimes overshadowed by his friend, Frank Benson, the great impressionist. Well regarded during his lifetime, Little painted seascapes, ocean storms, and landscapes. He was curator of art at the Essex Institute, was active in civic affairs, and, despite old age, painted camouflage on US warships during World War II. Little's portrait, painted by his old friend Frank Benson, hangs in Salem's Peabody Essex Museum. (Courtesy of A. Carr.)

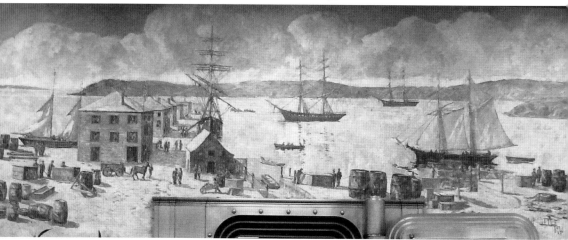

 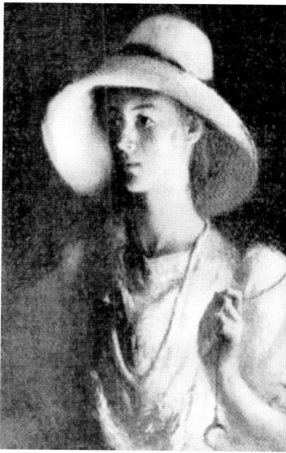

Frank W. Benson (1862–1951)

Benson was one of America's greatest and most famous impressionist artists, and a son of Salem. From the School of the Museum of Fine Arts in Boston, he went on to study at the Académie Julian in Paris. His greatest influences were Vermeer and Monet. In 1886, with his friend and artist Philip Little, he taught art in Salem, painting inspiring and luminous subjects that are recognizable today such as the portrait of his daughter above right. Successful and famous throughout his life, Benson lived on Chestnut Street near Little. The great art critic William Gerdts once wrote: "Frank Benson painted . . . images alive with reflections of youth and optimism, projecting a way of life at once innocent and idealized and yet resonant with a sense of certain, selective realities of contemporary times."

Sarah Symonds (1870–1965)

Symonds was born into one of Salem's oldest families. After graduating from Emerson College, she set up a studio in Salem in the restored John Ward House, where she produced bas-reliefs, striking miniatures, and cast-iron sculptures that commemorated Salem scenes. She gained a reputation for quality art souvenirs. At her Colonial Studio, she successfully marketed her work, achieving celebrity status in her later years.

Eleanor Meadowcroft (1939–)

Born in England, Meadowcroft came to America with an arts degree. She settled in Virginia, where she fashioned primitives on wood and sold them to galleries and high-end furniture companies as decorative accessories. When she moved to Salem in the 1960s, she continued as a prolific artist whose gentle, sometimes primitive style appeared on book jackets and in galleries in Manhattan, Salem, England, and Switzerland.

John Fogle (1943–)

Well known as an accomplished photographer and the artistic director of Salem Theatre Company, Fogle has won the Hatch Award from the Art Directors Club of Boston, a Samuel Chamberlain Award for Photojournalism, and awards in France and England. With a master's degree in film from Boston University, he has worked in film exhibition, distribution, and production. Semiretired, Fogle still produces, directs, photographs, teaches, and does voice-overs. (Courtesy of John Fogle.)

Sheila Farren Billings (1952–)

Educated at Salem State University, Billings has taught elementary and high school art. She wrote and illustrated *Salem: Witch City?*, still used in the Salem schools' social studies curriculum. Under the name The Sisters Farren, she and her sister have collaborated on the *Work-A-Day Week* books, which explore adults' everyday occupations. An award-winner, Billings has consistently been juried-in by the curators of Salem museums and the Salem Arts Association. (Courtesy of James Goncalves.)

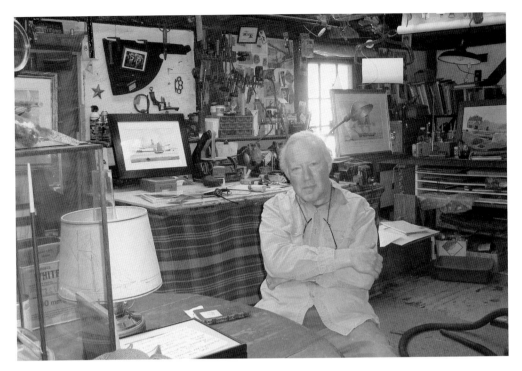

Racket Shreve (1944–)

Warren "Racket" Shreve is a true Salem legend whose maritime art has made a decided impact on Salem and the international art world. Shreve is well known for combining his life with art, antique cars, and classic boats. He hails from a long line of old Yankee Salemites and still resides in the home he grew up in. His work shares the themes of maritime artists of old and is saturated with a smooth luminosity and discerning brush strokes. His ships and seascapes are robust and breathtaking. He and his good friend, artist John Hutchinson, have often coexhibited their works at hospitable and sometimes amusingly cavalier art-themed venues in both their Salem homes. Together, they have contributed more to capturing the appeal of East Coast and North Shore waterways than many living artists.

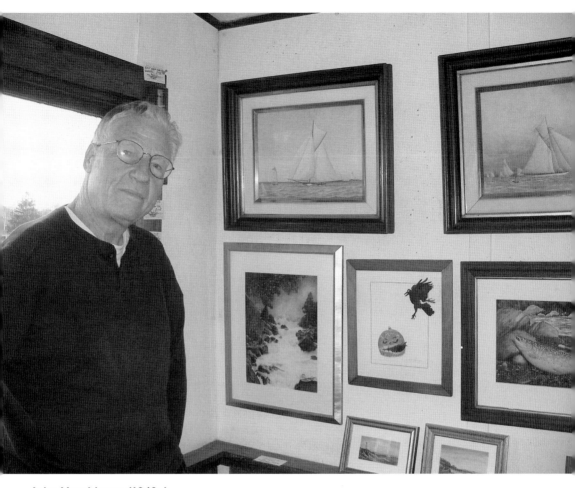

John Hutchinson (1940–)

Hutchinson is an award-winning artist whose works include seascapes, still-lifes, portraits of his own children, animals, landscapes, old boats, and cars, like the "woodies" of the 1960s. Down-to-earth and not taking art or life too seriously, he and his artist friend, Racket Shreve, have exhibited their work at theme-based art shows that they hatched 30 years ago. They refocused their "serious" artwork with a tongue-in-cheek approach and blended the high- and lowbrow platforms of the art world. They both believe art is for the masses and, together, have exhibited their blue-ribbon-caliber art alongside their cartoons of sailing vessels and miscellany. These two engaging, award-winning, and listed artists have cleverly staggered their artistic talents for the benefit of both those who know everything about art and those who know very little about art.

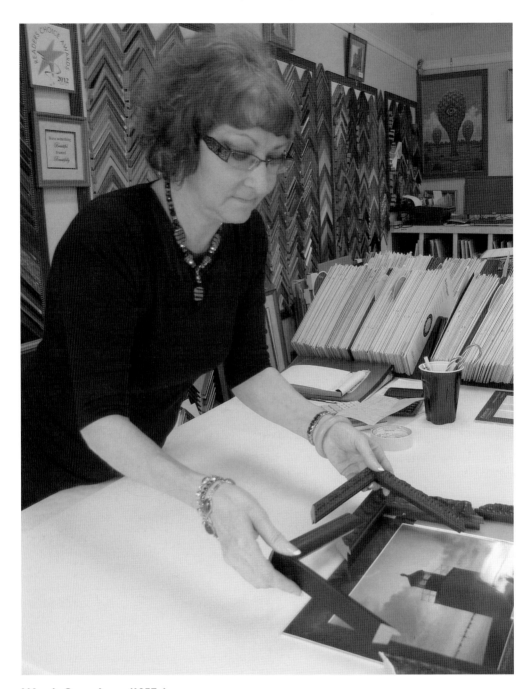

Wendy Snow-Lang (1957–)
An artist and author, Snow-Lang began working at The Art Corner in 1988 and purchased the business in 2005. She considers the fine craft of framing as an art in itself and has perfected it over the past 25 years. A founding member of Salem Arts Association, she exhibits her own and her husband, Charles Lang's, art. She is known throughout Salem for advancing the arts and moderating the successful North Shore Writers' Group in her shop. In 2008, a fire gutted the building, but she rebuilt it from the ashes and improved the space to resume the services at which she excels. (Courtesy of Elaine Snow.)

Charles Lang (1959–)
Charles is a gifted, self-taught artist who specializes in traditional, science fiction, and horror illustration. His influences range from Norman Rockwell to Jackson Pollock. Lang founded the annual Terror Fantasies Halloween Art Show and is a founding member of the Salem Arts Association. He launched Gallery 10/31, an extension of his Terror Fantasies Show. Some of his works are on permanent exhibition at The Art Corner. (Courtesy of Wendy Snow-Lang.)

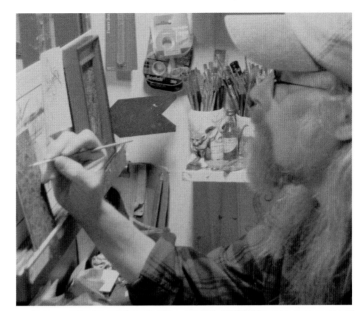

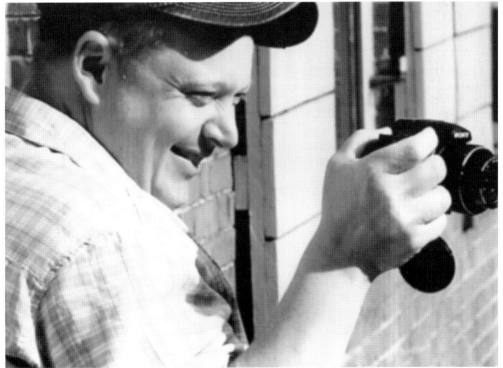

John Andrews (1974–)
Andrews has always had a passion for photography, seizing those moments in time and creating some of the most poignant, funny, and fascinating images of, and for, Salem, especially within social media outlets. With his company, Social Palates, he has become Salem's photographer-about-town, capturing "those events and happenings that really show the beauty of the people and the land of this historic city." (Courtesy of Henry Zbyszynski.)

Christopher Jon Luke Dowgin (1972–)

Dowgin conducts tours through Salem's infamous tunnels, writes charming and peculiar fairytales about Salem, plays exotic musical instruments, runs his Salem House Press, and paints en plein air at the Willows. The breezy text and quirky illustrations of his books, *A Walk Through Salem*, *A Walk Above Salem*, and *A Walk Under Salem*, show his art to be fanciful, ethereal, and fun. (Courtesy of Tom Uellner.)

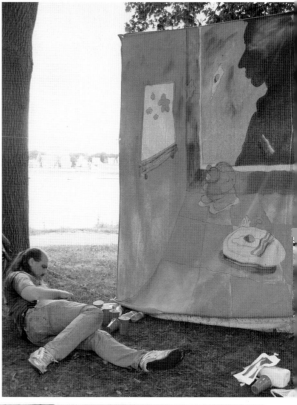

Henry Zbyszynski (1942–)

Hank Zbyszynski is a Salemite whose photographic art is everywhere, including in his book *Salemites: Photographs of the People of Salem, Massachusetts and Their Visitors*. His images have appeared in numerous publications; one of his photographs was used in Arcadia Publishing's *Fenway Park*. Zbyszynski is president of the Salem Arts Association and exhibits frequently, including his "inspiration exhibits" at the Peabody Essex Museum. (Courtesy of John Andrews, Social Palates.)

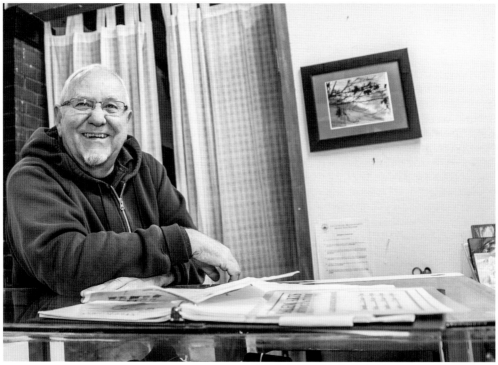

CHAPTER THREE

Literature

It is not down on any map; true places never are.

—Herman Melville

Half-way down a by-street . . .
stands a rusty wooden house,
with seven acutely peaked gables

—Nathaniel Hawthorne

Salem has a strong sense of place in any direction, whether guiding a visitor down Turner Street to Hawthorne's *House of the Seven Gables*, as in the epigraph above, or to Mall Street, where he penned *The Scarlet Letter.* It is maybe something about the direction writers take, and possibly nowhere else is this more evident than in Salem. The sense of place is tangible, immediate, and vibrant. Salem has generated some fine authors or has directed others to take up residence here. In Salem, it is hard not to write, so visceral is the overriding sense of inscribing words from mind to pen to paper.

Libraries have many works by authors who live or once lived in Salem. Of course, Nathaniel Hawthorne is Salem's favorite son, but Salem has, and is still generating, an abundance of authors who anticipate direction from this corner of the world, where those palpable literary vibrations seem to be in the air. Local talented writers of the past have included America's first poetess, Anne Bradstreet; Salem's witchcraft judge, Samuel Sewall; and the lovelorn, romantic Charles Benson. More recent scribes include Brunonia Barry, Jim McAllister, Bonnie Hurd-Smith, Margaret Press, David Goss, John Goff, and Bob Booth.

Local artists, academics, and businesspeople are also published authors. Consider artist and businesswoman Wendy Snow-Lang, musician Maggi Smith-Dalton, Egyptologist Tim Kendall, and attorney Neil Chayet, to name a few. Salem seems to bring out the pen and paper or laptop in so many people.

To call the act of writing a labor of love is fairly trite; calling it an act of martyrdom, for some, may be more accurate. Writing is a solitary function and may be found in any given home, whether stately mansion or chilly garret. The city is filled with those hopeful pioneers pounding keys, with drifting beliefs and naked emotions, striving to recreate themselves, their characters, their angst, or their subjective truths. And so they write. Writing is like breathing, and the air in Salem virtually nourishes its writers with it. Oh, Salem is different; it can be more a state of mind or a true directional current. But it is far removed from uninspiring geographies.

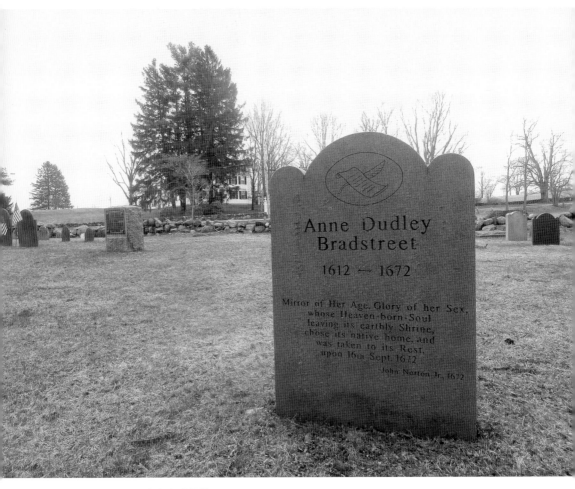

Anne Bradstreet (1612–1672)

Bradstreet sailed with her family from England to Salem on the HMS *Arbella* and has the distinction of being America's first woman poet. Her parents were forward-thinking people who encouraged her to read and learn. Bradstreet was a free thinker, possibly a "closet feminist," but with no ill will toward men. She was self-educated, deeply devoted to her husband and children, and had a fervent faith in God, all of which became the overriding themes in her poetry. Literary folklore maintains that her poems were surreptitiously brought to England, where they were published. In the book's preface, her talent is discreetly acknowledged, so as not to endanger her as "unwomanly:" "The Tenth Muse Lately Sprung Up in America, By a Gentlewoman of Those Parts." Her poetry was widely received and praised, much to this accomplished gentlewoman's satisfaction.

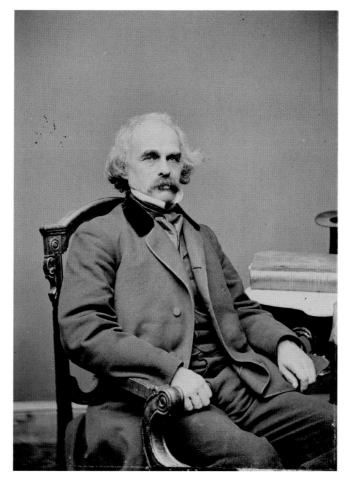

Nathaniel Hawthorne (1804–1864)

Arguably Salem's most famous son, Hawthorne was four years old when his sea captain father died of yellow fever in Suriname, South America. For the next 10 years, Nathaniel and his mother and two sisters lived with maternal relatives, the Mannings, one street over from his birthplace. Hawthorne's birthplace has been moved to the grounds of the House of the Seven Gables, which was made famous by his book of the same name. A descendant of an unrepentant witch trial judge as well as mariners, Hawthorne drew on his own and Salem's history to give the world some of the finest literature produced in America. After a sickly youth, he attended Bowdoin College, graduating in 1825. While there, he developed lifelong friendships with Horatio Bridge and the future president, Franklin Pierce. Retuning to Salem after college, Hawthorne wrote stories with little success. In 1842, he married Sophia Peabody, an artist and writer. They moved to the old Manse in Concord, where they stayed until 1846, when they returned to Salem with his appointment as surveyor of the Port of Salem. They had three children, Una, Julian, and Rose.

In 1849, he was fired when a Whig, Zachary Taylor, was elected president. Writing full time, Hawthorne produced *The Scarlet Letter*, followed by *The House of the Seven Gables* and *The Blithedale Romance*. In 1850, he moved to Lenox, Massachusetts. Though he left Salem, the town's prism remained strong in his writings throughout his life. These books cemented his place in American literature. In 1853, Pres. Franklin Pierce appointed him US Consul to Liverpool, England. In 1857, Hawthorne left that position and traveled in Europe, living in Rome and Florence before returning to Concord, where he continued to write. In 1864, while on a trip with Franklin Pierce, Hawthorne died in his sleep in New Hampshire. He is buried in Sleepy Hollow Cemetery in Concord, Massachusetts. (Courtesy of LOCPPD.)

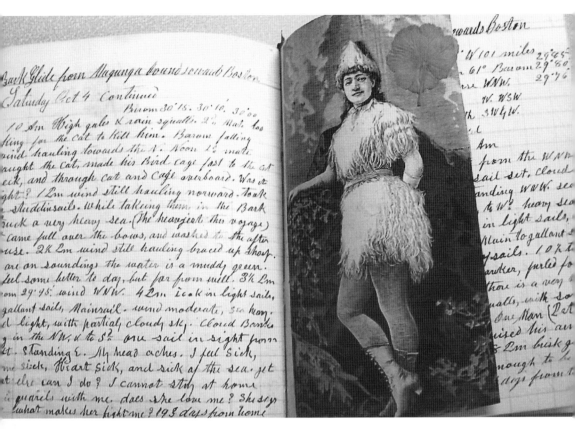

Charles Benson (1830–1881)

Descended from African slaves, Benson was a freeman in Salem. He was determined to sail the seas, until he met the love of his life, Margaret Jenny Benson. "My Jenny Pearls . . . a darling wife, she is my love, my joy, my life." At sea, he was frequently apart from his family, which resided on Pond and Rice Streets. He adored Jenny with such intensity, he wrote copious intimate and heartrending letters home. His stirring letters, journals, and illustrations speak volumes about the man, seaman, and family provider. While onboard the ship *Glide*, he wrote: "My mind wanders home to Salem . . . oh How I should like to be with you." Charles Benson, known for his maritime skills and for improving the well-being of shipmates, died at 51. He is best remembered in the poignant love letters he wrote from sea. (Courtesy of Yale Beinecke Library.)

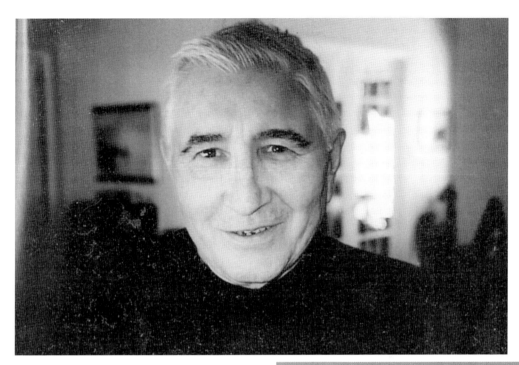

Robert E. Cahill (1934–2005)

After working in advertising and public relations, Cahill switched to public service. He served as city councilor, state representative, and Essex County sheriff before retiring early in 1981. Seeing Salem's potential as a tourist destination, he opened the Salem Witch Dungeon Museum in 1970. This led the way for re-imagining Salem's tourist appeal and set the stage for the annual Haunted Happenings, which he is credited with starting. He wrote 30 or more books chronicling New England tales. In 1994, he opened the New England Pirate Museum. An extraordinary storyteller, he has left an enduring legacy in Salem. (Courtesy of Keri Cahill.)

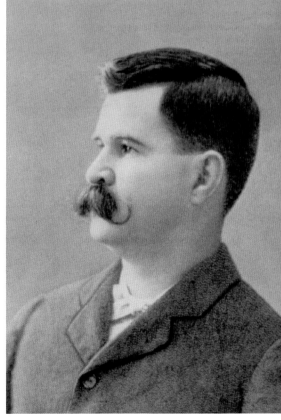

Robin Damon (1862–1920)

A Salem businessman, Damon started the *Salem News* in 1880 with just a four-column spread. His enterprise expanded and was moved to the Brown Block on Essex Street. The newspaper eventually became the "largest and best penny paper published in New England." Damon was not only a publisher, he was enamored of the new motorcars and enthusiastically wrote about them. Ironically, he died in a motoring accident in Rowley.

Timothy A. Kendall (1945–)
Kendall, a scholar of Egyptology who has done curatorial work at the Museum of Fine Arts, was motivated to write several books on Egyptian antiquities. Recently, he wrote on the witchcraft trials for a calendar he created for 2013. He writes of Beadles Tavern near today's 65 Essex Street, where meetings, intrigue, and even some pretrials of the accused occurred. His next adventure takes him researching artifacts in Sudan.

Roberta Chadis (1949–)
Chadis's written and photographed works, especially the popular *Good Boy Jesse*, about a golden retriever, have been published in English, Spanish, and Italian. Chadis's next book, *Written on a Kiss*, is a tour de force of photographs of couples warmly canoodling and includes her attending narrative. It is also bound for success. She cohosts *11-11 Chaga Tea* on YouTube and interviews notable people around Salem. (Courtesy of Roberta Chadis.)

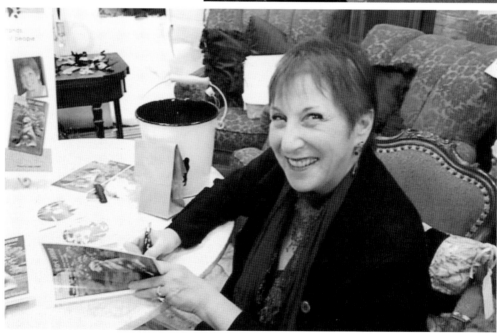

Margaret Press (1947–)

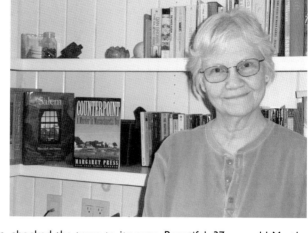

Margaret Press's whodunits are almost always set in Salem. She has authored numerous short stories and mystery novels, but she is perhaps best known as the author who undertook the sensitive tale of the death of Martha Brailsford at the hands of sociopath Thomas Maimoni. The nonfiction book is titled *Counterpoint: A Murder in Massachusetts Bay.* Press, accustomed to writing in a fictional mystery genre, found that dealing with a horrible but factual event seemed more improbable and unfathomable.

What occurred in 1993 in the Willows, a residential section of Salem, shocked the town to its core. Beautiful, 37-year-old Martha Brailsford was murdered by Tom Maimoni and tossed from his boat, *Counterpoint.* The story goes that a Salem witch, Laurie Cabot, assisted police in locating Brailsford's body, which had been missing for some time. Lobsterman Hooper Goodman found the remains of Martha Brailsford while hauling his lobster traps out of Salem Harbor. The police eventually captured Maimoni (below), who was tried, convicted, and imprisoned.

Press was so immersed in the case, learning more than she could have imagined about human nature, that it greatly impacted her fiction writing. Interviewing Maimoni in prison, she found him a polite and charming conversationalist—the sometimes-veiled characteristics of a socio/psychopath.

Her novel *Requiem for a Postman* and her entry in *Salem: Place, Myth and Memory* are still in print. She won the L. Blanchard Award for "Family Plot" in the anthology *Dead Fall.* She has been a consultant on the Brailsford murder case for television's *Unsolved Mysteries* and *City Confidential.* Margaret Press holds a doctorate in linguistics from UCLA, still lives in Salem Willows, and still writes while balancing a full-time career. (Courtesy of Kirk Williamson.)

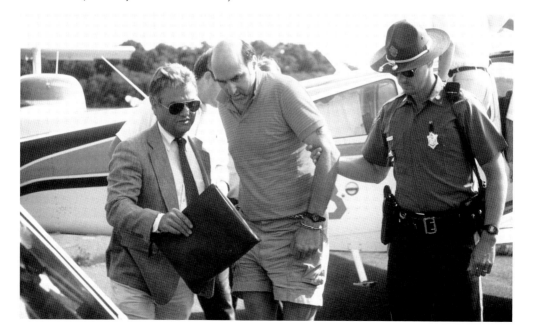

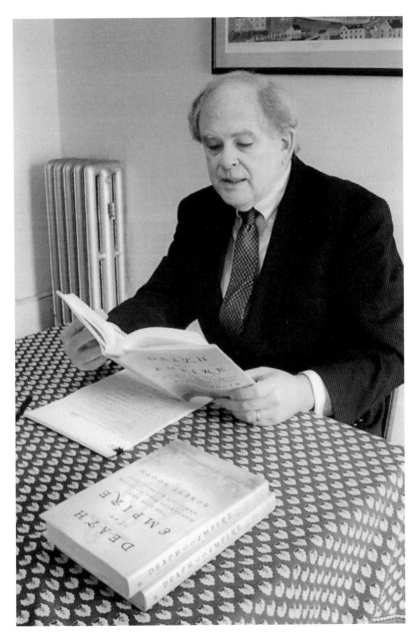

Robert Booth (1951–)

Educated at Harvard and Boston University, Booth worked summers as a lobsterman and sailing instructor. He has been involved with the written word since his post-college days working as a pressman at a printing house, as a Salem newspaper reporter, and having established himself as an architectural-historical consultant. The Globe Pequot Press published his guidebook, *Boston's Freedom Trail*, still in print since 1982. His masterwork, *Death of an Empire*, on Salem's maritime glory days and eventual demise, was on the *Boston Globe* bestseller list. In 2012, Booth was awarded the History Book Prize of the New England Society of the City of New York for his bestseller. He continues to lecture on architecture and history, writes numerous articles, and produces testimonies on historic buildings in Salem and farther afield. (Courtesy of Bob Booth.)

Brunonia Barry (1950–)

Following in the footsteps of Nathaniel Hawthorne, no other author has done as much to spotlight Salem as Brunonia Barry. Her book *The Lace Reader*, a blockbuster on the *New York Times* bestseller list, has enjoyed international acclaim, being translated into 30 languages.

Born in Salem, Barry studied at Green Mountain College in Vermont, the University of New Hampshire, and Trinity College in Dublin. In Chicago, she distinguished herself running promotional campaigns for Chicago's famed Second City and Ivanhoe Theatre. In California, she wrote scripts and became involved in the screenwriting side of filmmaking. But the lure of Salem enticed her back. In 1995, she and her husband, Gary, returned, putting down permanent roots in her beloved city. They collaborated on creating award-winning word, logic, and visual puzzles.

Salem has a tradition of prompting emerging and established writers to set pen to paper. Barry worked on the teenage fiction series *Beacon Street Girls*. She and other authors collaborated in creating the series, with Barry in charge of character development and directing how the series would proceed.

Her first novel, *The Lace Reader*, which is set in Salem, is currently being adapted into a Hollywood film of the same name. Its anticipated release is sometime in 2015. Following that book's runaway success, her second novel, *The Map of True Places*, is equally captivating and also set in Salem. Her third novel is scheduled to go to press this year. Barry's intriguing plots, with notable and oh-so-human characters and underlying themes of the somewhat shadowy sides of human nature, folly, trauma, a sense of loss, even suicide, are page-turners. Those darker elements, however, are set within her persuasive narrative. The stories' ultimate satisfaction overcomes any mystical shadows with humor and redemption.

Brunonia Barry makes no secret of her love affair with Salem: "Where else can you live so fully with history? Here the way of life and human nature is the same as it's always been. I can walk around Salem, watch the world go by with its countless models of humanity passing by me, its history, its architecture, the *Friendship* of Salem docked in our harbor. All of which gives me more and more ideas for my stories. As old as Salem is, it never grows old for me." (Courtesy of Tattered Cover Book Store, Denver.)

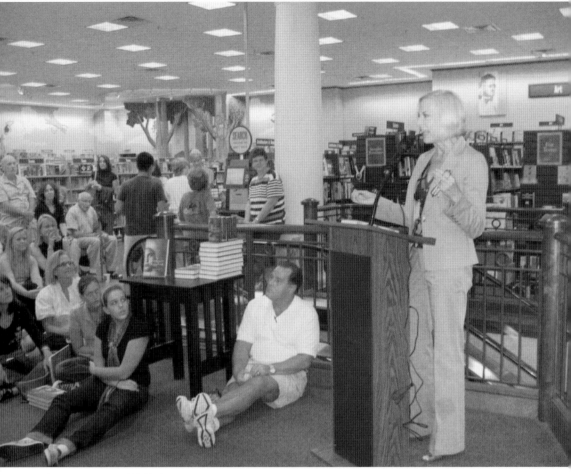

Kathleen Kent (1953–)

Kent, a ninth-generation great-granddaughter of Martha Carrier, an accused "witch" of 1692, has breathed Colonial America's sensibilities into 21st-century reality with her first Salem-based novel, *The Heretic's Daughter*, followed by *The Traitor's Wife*. Both novels have appeared on international best-seller lists and been translated into several languages. Kent has said, "From the time I was a child, I remember hearing about . . . Martha Carrier . . . from my mother and grandmother . . . a brave and unfortunate victim of intolerance, superstition and greed." *The Heretic's Daughter* is based on Martha's dogged resolve and innocence. Her third novel, *The Outcasts*, is due in 2013. (Courtesy of Audrey Hickman.)

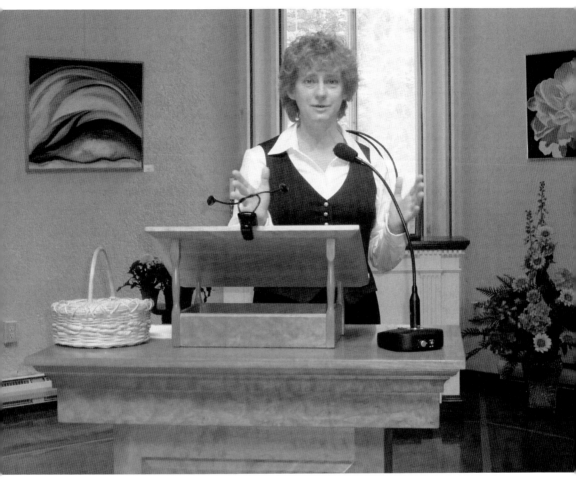

Bonnie Hurd-Smith (1961–)
An ardent devotee of Salem, Hurd-Smith has spoken and written about the town for years. She created and wrote the book *Salem Women's Heritage Trail*, led walking tours, delivered sermons, lectures, and talks, and has directed and promoted special events. She has consulted or volunteered for cultural institutions, including the Peabody Essex Museum, Pioneer Village, and Historic Salem Inc., and has assisted in the creation of interpretive signs for Salem's neighborhoods. Her public relations company, History Smiths, promotes people and businesses in the use of their history with innovative, results-oriented strategies and objectives. Her most recent book, *We Believe in You! 12 Stories of Courage, Action, and Faith for Women and Girls*, features two women from Salem history. Smith has authored several other books, most notably her scholarly works and countless lectures on Judith Sargent Murray. (Courtesy of Bonnie Hurd-Smith.)

Michael Rutstein (1965–)

A decade ago, Captain Rutstein brought his passion for history to life by having a replica of the schooner *Fame*, a privateer vessel, built. The *Fame* was the first Salem privateer to capture an enemy ship in the War of 1812. The new *Fame* offers cruises, providing sightseeing with a generous dose of history. Captain Rutstein has written two books about the War of 1812, the most recent of which, *The Privateering Stroke*, was illustrated by Salem's own Racket Shreve. (Courtesy of Michael Rutstein.)

Wendy (Cincotta) Altshuler (1967–)

In starting the Children's Writing Group while living in Salem, Altshuler wrote her popular series of books on the Evergreen adventures featuring her ubiquitous tree character, Sir Two. *Christopher's Adventures in Evergreen* (also adapted for the stage), *Return to Evergreen*, *The Rescue of Georgeonus*, and *Nadia's Heart (Part One)* are in their second printing. The fascinating Sir Two has been integrated into stop-motion animation on environmentally themed subjects for children. Her mother, artist Eva Cincotta, illustrated her books.

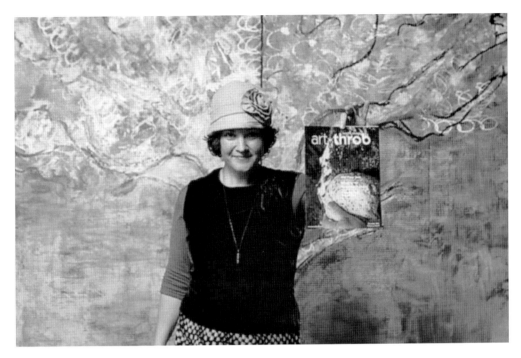

Dinah Cardin (1974–)

With a master's degree in journalism from Boston University, Cardin was the first staff writer for the *Salem Gazette*. Arts and writing feature prominently in her career, which includes teaching writing at the college level. In creating *North Shore Art*Throb* magazine, she assembled a group of local, essentially pro bono contributors who created an online and glossy arts magazine and a voice within the mainstream media that would be accessible to everyone. (Courtesy of 52 Pho.To.)

Damien Echols (1974–)

In *Almost Home* and *Life After Death*, Damien Echols reveals his anguish with words both lyrical and profound. At 18, he and two others were accused of a heinous crime in Arkansas, despite inadequate evidence and inflammatory prejudices against them. Echols spent 18 years on death row, fighting for his innocence. He lives in Salem with his wife, Lorri Davis, whom he married while in prison. Echols has said, "We loved [Salem] from the moment we saw it. It's a city that has learned from its mistakes . . . and a town of great people."

Alan Hanscom (1954–)

Since age 10, when he first got permission to use his father's Royal typewriter, Hanscom has been fascinated with writing. He began writing seriously about science fiction and paranormal subjects, and he attributes his literary guidance to his Salem writing circle, the North Shore Writers Group. His first novel, *The Compass Has Eight Points*, was followed by his recent work, *Sharon of Two Salems*, which is receiving rave reviews.

Katherine Howe (1977–)

Howe is a descendant of Elizabeth Proctor and Elizabeth Howe, both accused of witchcraft. Howe earned her doctorate in American and New England Studies at Boston University. Her best seller *The Physick Book of Deliverance Dane* has shadows of Salem's 1692 infamy. Her latest novel, *The House of Velvet and Glass*, is also creating a literary stir. Howe hosted *Salem: Unmasking the Devil* for television's National Geographic Channel.

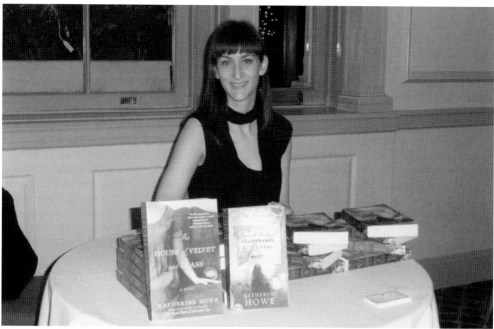

CHAPTER FOUR

Military and Public Service

Never doubt that a small group of thoughtful, committed citizens can change the world. Indeed, it is the only thing that ever has.

—Margaret Mead

Salem has always had a sense of "We're in this together." In 1630, the pilgrims, readying the ships to land, paused to listen to Governor Endecott's sermon on this settlement being a city on a hill. Governed by Christian charity for one another, this shining city would be a beacon to others. In a time of no social services, the townspeople of Salem voted to support people unable to work, as well as widows and children of those lost fulfilling their military duty.

As Salem grew, there were always people willing to work for the betterment of all. The clergy often took the lead not only in providing charity, but encouraging education and health interventions during epidemics, as well as the formation of an almshouse to care for the indigent. People like Reverend Bentley, who routinely gave away most of his salary, were exemplars of unselfishness.

While Salemites were blessed with never having had to fight a battle in their town, they have been deeply involved in military service. As was recently confirmed by the federal government, Salem is the birthplace of the National Guard, formed before the colonies became the United States. Salem men and women have heeded the call to service for every war this country has fought. While assessed numbers to serve, they often went beyond the call in volunteers willing to sacrifice for others. Literally, many thousands have served over the years. The people of Salem funded, by subscription, one of the first ships of the Navy.

During the heyday of the East India trade, when fortunes were being made, Salemites stepped forward to start and fund charitable institutions. John Bertram, a wealthy merchant, helped start and fund Salem Hospital and homes for the aged and fueled assistance programs. He, like others, saw a need and answered it. Through the years, people like Caroline Emmerton, the Remond family, Ralph Dalton, and Lucy Corchado have sought to respond to the changing face and needs of Salem. That golden vein that runs through Salem's days continues to the present, with people, both rich and of lesser means, stepping forward to help. Some touch the local community, while others, like Eric Klein, touch the world.

This chapter highlights only a sample of the thousands of Salemites, both living and dead, who have served the needs of the country in public and military service. Many have paid the ultimate price. They, and all those who step forward to help, have made the words of Governor Winthrop ring true. They make Salem shine all the brighter.

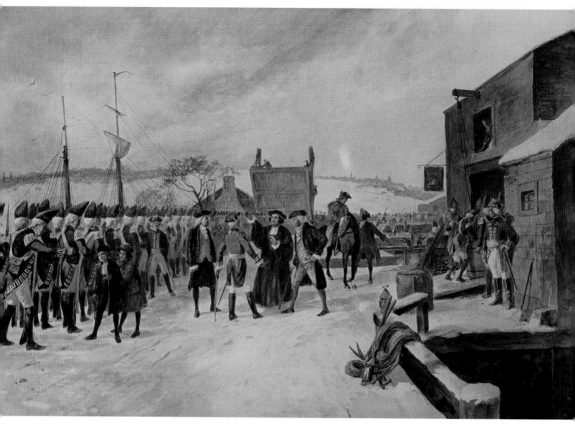

Col. David Mason (1726–1794)

A Bostonian by birth, David Mason anticipated attending college. His father's death, however, prevented him from pursuing academics. Instead, he apprenticed to learn fine painting and gilding. At the end of his apprenticeship, he painted portraits, but soon decided to pursue his love of science. A family friend to Benjamin Franklin, Mason was fascinated by his studies of electricity and became expert in the field. This passion led him to do a number of experiments and give lectures on electricity in Boston and Salem.

At the outbreak of the French and Indian War, he joined the Provincial Army in 1757, pursuing gunnery and the engineering challenge of cannons. He commanded a cannon battery at Fort William Henry. When the fort fell, he was captured by Indians bent on killing him, until he showed them how he could light a fire with a lens. Eventually, he escaped and made his way home. He moved to Salem in 1771, where he was a leader in espousing the growing revolutionary views.

Mason served as an engineer, which was the first military appointment of the American Revolution. He secretly purchased 17 cannons, carriages, and ammunition and stored them at his home. Colonel Leslie led a force of British military to Salem to seize these guns. After a lengthy confrontation with Mason and other colonial leaders, Leslie retreated: this confrontation is depicted in the painting above, "The Repulse of Leslie at the Old North Bridge" by Frederick Bridgman. Mason later deposited the ammunition stores in Concord, which again became the target of the British. This time, however, there was no retreat, and the Revolutionary War began. In 1775, Mason was given the rank of lieutenant colonel in the Continental Army. The following year, he was charged by Washington with establishing the first military arsenal, which he operated at Springfield, Massachusetts. Following the war, he opened a West India Goods Store in Boston, but struggled to make a living. In 1789, he sought a pension from Congress for his years in the military. Due to a fire in the records office, he was never paid for his services. His health deteriorated, and he was confined to home for two years before he died in 1794. (Courtesy of LOCPPD.)

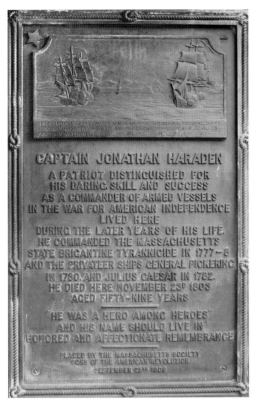

Jonathan Haraden (1744–1803)

Haraden was a successful Salem merchant who joined the Massachusetts navy in 1776 on the sloop of war *Tyrannicide*. After a year, he was given command and became a scourge to the British navy. In 1778, he took command of his own privateer and was one of the most successful of all privateers. He captured ships much larger and more well-armed than his through his boldness and bluffing.

Caroline Plummer (1780–1854)

Plummer was one of Salem's greatest philanthropists. In 1813, her sole surviving brother, Ernestus, returned from Russia, where he had amassed a sizeable trading fortune. When he died in 1823, she put her inherited wealth to use helping others. Her philanthropies were often in her brother Ernestus's name. She endowed Harvard's Plummer Professorship, the building of Plummer Hall, and Salem's Plummer Farm School for delinquent boys.

John Remond (1785–1874)
Remond and his wife were free blacks who ran a very successful catering business at Hamilton Hall. He started the Salem Anti-Slavery Society in 1834. When his daughters were refused admittance to high school because of race, he effectively advocated for changing the law in "abolitionist" Salem. This change took six years, during which his children were educated in Rhode Island. They returned to Salem in 1841 when desegregation occurred.

Charles Lenox Remond (1810–1873)
A gifted orator who spoke at antislavery meetings throughout the Northeast, Charles Remond was the leading black abolitionist before Frederick Douglass. He represented antislavery interests in England, traveling there in 1840 to espouse the cause of freedom. He was also an important black recruiter for the Union Army's 54th and 55th Massachusetts Regiments, the subject of the film *Glory*.

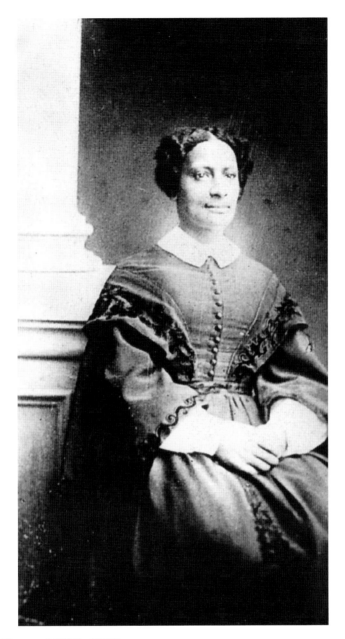

Sarah Parker Remond (1826–1894)

John Remond's daughter and Charles's sister, Sarah Remond started the Salem Female Anti-Slavery Society in 1834. In 1853, while at a Boston opera theatre, she refused to be moved to the negro-only section and was forcibly removed and pushed down a flight of stairs. She sued and won a settlement, including the desegregation of the theater. A powerful antislavery speaker, she was chosen to travel to England to foster antislavery support in 1858. While touring and speaking, she attended Bedford College for Women (London University). She remained in England, garnering antislavery support and donations before, during, and after the Civil War. In 1866, she stayed in Europe, enrolling in Italy's Santa Maria Nuova Hospital, where she became a doctor. Remond remained in Florence, Italy, married an Italian, and practiced medicine for 20 years.

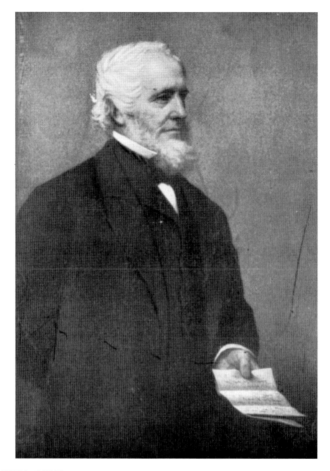

John Bertram (1796–1882)

Salem's greatest benefactor, Bertram was born in the former French-speaking Jersey Island off France and emigrated with his family at age 11. Through a series of mishaps, his family experienced poverty and struggled to get by. He was removed from school so that he could translate for his carpenter father. At age 16, he signed on to the privateer ship *Hazard* as a cabin boy during the War of 1812.

By the age of 28, he had worked his way up to captain, displaying the abilities to negotiate, make sound trades, and stay ahead of his competitors. Amassing enough wealth, he retired from the sea at age 36, returned to Salem, and started a shipping business, where he continued to excel, amassing a sizable fortune that made him the wealthiest merchant in Salem. While he made a fortune in the South American gum copal trade, the California Gold Rush trade, and the railroads, he never forgot his roots as a poor immigrant in Salem. He was often the first and most generous in giving to the community. He founded a Home for Aged Women, now called Brookhouse, in 1860. He contributed a building and capital to open Salem hospital in 1873. In 1877, he founded a Home for Aged Men, now called Bertram House. He established accounts to help pay for winter fuel for the poor and ensured that it would be funded after his death. In 1882, he donated a home for working women to the Woman's Friend Society. He was a generous supporter of The Children's Friend Society, one of Salem's earliest social service agencies. He was also a member of the Salem Common Council and a state representative. His legendary generosity of money and time continued after his death, when his wife and daughters donated his mansion on Essex Street to the city for use as a public library, which continues to this day. The above portrait is from an oil painting by Edward Parker.

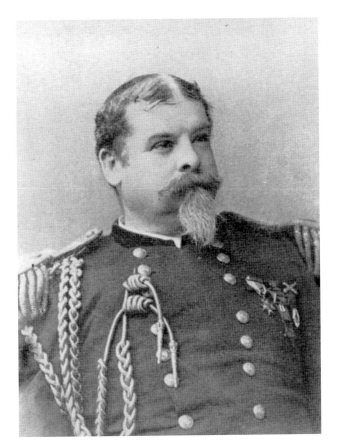

Adj. Gen. Samuel Dalton (1840–1906)

Born and raised in Salem, Dalton graduated from Salem High School in 1856 and worked in his family's leather businesses. When the Civil War broke out, he joined the Salem Cadets and, with other local soldiers, recruited more than 100 men from Salem and surrounding towns, including his uncle, Eleazer Moses Dalton, for the 1st Massachusetts Heavy Artillery.

Several of Dalton's relatives served in the Union Army's infantry and heavy artillery battalions, including Col. J. Frank Dalton and Samuel's uncle Eleazer. The Cadets were eventually mobilized to Washington, DC, to guard the Capitol; however, combat farther south was becoming increasingly harsh. Battles near Richmond, Virginia, in the last few years of the war saw some of the worst fighting. During the devastation of Petersburg, Samuel's uncle Eleazer was killed on Jerusalem Plank Road; it was Samuel who found his uncle's body. The family legend goes that when Dalton saw his uncle's slain body, he ordered that it be treated with particular reverence when buried.

Following the Civil War, Dalton resumed his life in the family's leather business in Salem but still returned to the Salem Cadets. He was eventually promoted to the rank of lieutenant colonel when the company was officially designated as The Second Corps of Cadets. In 1883, Governor Butler appointed him adjutant general of Massachusetts with the rank of brigadier general. He was adjutant general for the next 22 years, until a year before his death.

Salem has bred many military men who have died or been wounded in wars. Many families have their heroes, including the Daltons of Salem. Indeed, Dalton Parkway honors those men. From the first Dalton to arrive on Salem's shores with his privateering activities during the American Revolution and the War of 1812, to the brave men who fought for the Union, in the Spanish-American War, World Wars I and II, the Korean War, the Vietnam War, and in the Middle East, Salem men still continue to defend their country with devotion and honor.

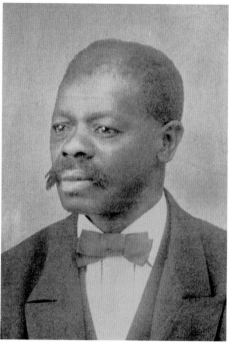

Rev. Jacob Stroyer (1849–1908)

Stroyer was born a slave in South Carolina. During the Civil War, he was one of 40 survivors of the 360 slaves used to fortify Fort Sumter during its bombardment in 1863. After the war, he was ordained a minister and sent to the AME church in Salem. To fund his studies, he wrote the best seller *My Life In The South*, which chronicled slavery. In 1890, he joined South Church in Salem, where he remained.

Caroline Emmerton (1866–1942)

In dedicating her life to charitable causes, Emmerton was involved in the settlement movement, helping immigrants through education and services. She purchased and restored the Turner-Ingersoll Mansion (House of the Seven Gables). The funds generated by this tourist attraction supported the settlement house. This blending of restoration and social service was a great success. Emmerton also rescued a number of other historic properties in Salem.

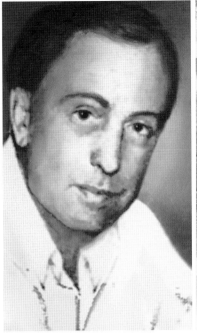

Ralph E. Dalton (1882–1957)

Born on Saunders Street, Ralph Dalton came from a proud and hard-working family whose predecessors were mariners, soldiers, and leather workers dating from the 1600s. A natural leader, Dalton was always motivated and productive, but when the Great Depression hit in the 1930s, he lost everything. Some accepted any job to feed themselves, and under those conditions, Dalton traveled the Northeast looking for work. His sojourns involved catching any passing train heading anywhere to earn an honest day's pay. For those unfortunate masses riding the rails, the term "homeless" got its first official use. Dalton found himself in the company of other unemployed men, referred to as hobos. Astonished by the pathos of his companions, Dalton vowed to never forsake them, even when the economy stabilized and he got back to work.

Following the Great Depression, in Manhattan and once again gainfully employed, Dalton kept his promise, spending the rest of his life advocating for homeless men. He began an ersatz "hobo college" on a shoestring budget, helping them with apprenticeships, acquiring presentable clothing for jobs, and providing a course in deportment when job searching. Dalton often spent his own salary to provide Thanksgiving and Christmas dinners for them. He founded The Forgotten Man Movement and gave countless speeches, from the slums to city hall. He tracked down jobs and provided food and shelter, even on his limited salary. His early promise to never forsake them became his life's work.

However kind and altruistic Dalton was, at age 75 and in fragile health, he was largely forgotten, even by those whom he had spent his lifetime serving. One night, he got up from bed and surprised burglars breaking into his apartment. They assaulted and bludgeoned him to death. Decades later, extended family members had his remains returned to Salem. At long last, Ralph Dalton was back to his birthright when he was interred in Harmony Grove Cemetery with his parents and brother. (Courtesy of the Dalton family.)

Mike Harrington (1925–) and Juli Lederhaus (1949–)

After 18 years of public service as a city councilor, state representative, and congressman, Mike Harrington turned his attention to another form of public service. He purchased the Hawthorne Hotel, which had fallen on difficult times. Bringing manager Juli Lederhaus on board in 1999, they refurbished it to a state-of-the-art facility while preserving its classic beauty and family-friendly atmosphere. Under their guidance, the Hawthorne joined Historic Hotels of America, and Harrington and Lederhaus maintained a dedication to its history and inspired their staff to "be the guest," to anticipate the perceptions and the needs of their guests. While maintaining this focus, Harrington and Lederhaus, shown here, have also become a force in Salem through their sponsorship of community activities, including their ongoing Salem Preservation Award presented to local residents who preserve the city's heritage.

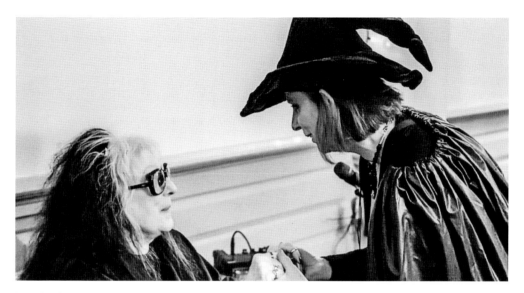

Laurie Cabot (1933–)

A self-proclaimed witch, high priestess of her mystical movement, Laurie Cabot is Salem's official witch and one of the nation's foremost witches. As high priestess, psychic, and businesswoman, she has been responsible for prophecies, privately and with law enforcement agencies. A Midwesterner by birth and a Salemite by cosmic rite, she knew from childhood she had psychic abilities that she could never ignore. She has been on television with Oprah Winfrey, Johnny Carson, and on the series *In Search Of*, to name a few. Cabot has been featured in countless newspapers and magazines, including a famous 1979 article and photograph in *National Geographic*. Despite her distinct mystical lifestyle, she is still on terra firma, involved in advocating for special needs children and other charitable causes. (Courtesy of John Andrews, Social Palates.)

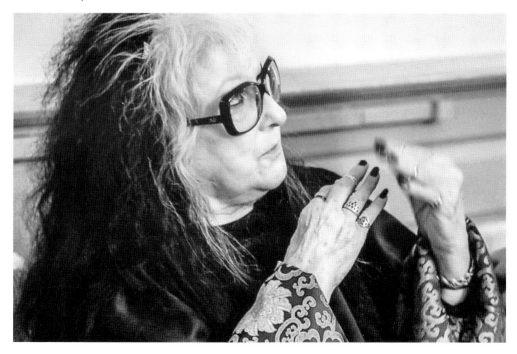

Joan Boudreau (1942–2007)

Amid the detriments of urban renewal, a few
voices argued for a better approach. Joan Boudreau
saw potential where others saw removable
obstacles. She led by buying and converting the
historic Lyceum building, slated for demolition,
and transforming it into a first-class restaurant.
President of the Salem Redevelopment Authority
for 14 years, she received the Hawthorne
Preservation Award in 2004. Boudreau left an
extraordinary legacy of community service.
(Courtesy of Kirk Williamson.)

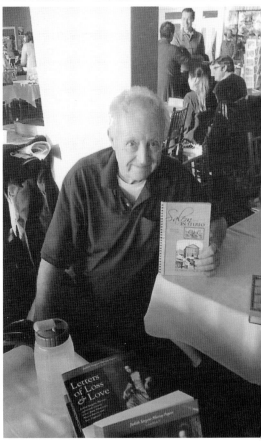

Nelson Dionne (1947–)

Dionne is Salem's legendary collector-archivist.
His knowledge far exceeds his collection, amassed
throughout his lifetime. Salem born and bred,
he has stockpiled postcards, local brochures,
two centuries of newspaper articles, books,
vintage photographs, even local businesses'
matchbook covers. He coauthored *Salem* in
Arcadia Publishing's Then & Now series, and
his latest book is *Salem in Stereo* (HardyHouse,
2011). Dionne won Historic New England's
Prize for Collecting Works on Paper in 2013.

Stephen M. O'Grady (1969–1999)

At 16, Stephen O'Grady began coaching Little League. His skill and enthusiasm soon made him vice president of Salem Little League. At 19, he became athletic director at St. John the Evangelist School while continuing his dedication to Salem Little League. Following Salem State University, he became executive director of the Boys and Girls Club of Salem, where he led a revitalization effort that saw the club grow rapidly. He always found time to coach and mentor kids and was involved in a number of sports and community organizations. His leadership and dedication made him a city favorite. He tragically died in a car accident. O'Grady Baseball Field is named in his memory. The Stephen O'Grady Foundation maintains his legacy of community service through its scholarship program. (Courtesy of Beth O'Grady.)

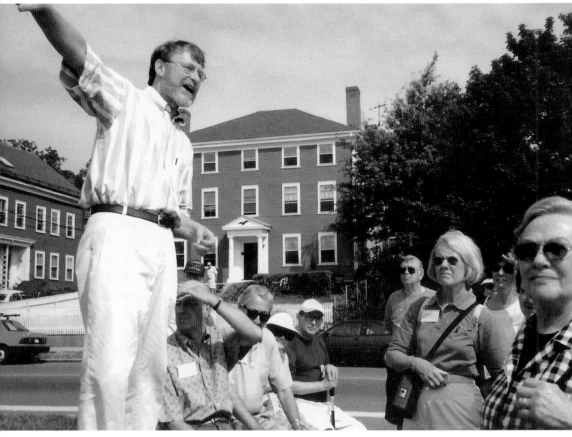

Jim McAllister (1950–)

McAllister is Salem's authentic and legendary Renaissance man. Known and liked everywhere, his energy is fueled by his love for this city, a love that is in itself contagious. A prolific author on history and art, McAllister has also been a newspaper columnist, a photographer, and a teacher, and has lectured extensively on the arts and on Salem's history. In 1983, he founded Derby Square Tours and still takes pleasure in escorting tourists around Salem. He has served as historic consultant to the city of Salem, Peabody Essex Museum, and Hawthorne Hotel. His books include *Salem: From Naumkeag to Witch City*, *Salem: Cornerstones of a Historic City* (coauthor), and the recently penned *Life with Scrubrush: A Dog's Story*. McAllister has won countless awards and is consistently generous in assisting anyone seeking information on Salem. (Courtesy of Jim McAllister.)

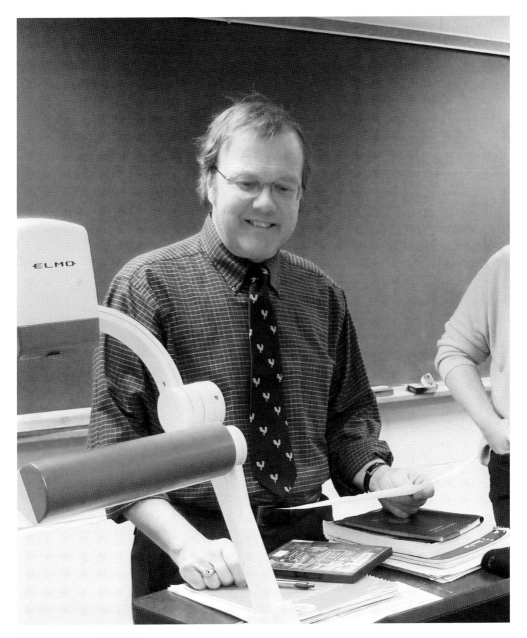

K. David Goss (1952–)
Goss is director of museum studies at Gordon College and professor of history there, as well as at Salem State University. He has been a driving force around Salem for years. A real trailblazer, he has brought old Salem to new life through his books, historical venues, and museum expertise. In 1976, he was a park ranger at Salem's Maritime Site. He then served as director of education at Essex Institute, where his interpretive and interactive theatrical event, *Cry Innocent*, was conceived. For 10 years, he was museum director at the House of the Seven Gables and has been a driving force in breathing new life into Pioneer Village, Salem's living history museum. If that weren't enough, Goss tackled the project of creating the recently established Salem Museum in Old Town Hall. Professor Goss has authored several books, most recently *The Salem Witch Trials: A Reference Guide*. (Courtesy of Mary Ellen Smiley.)

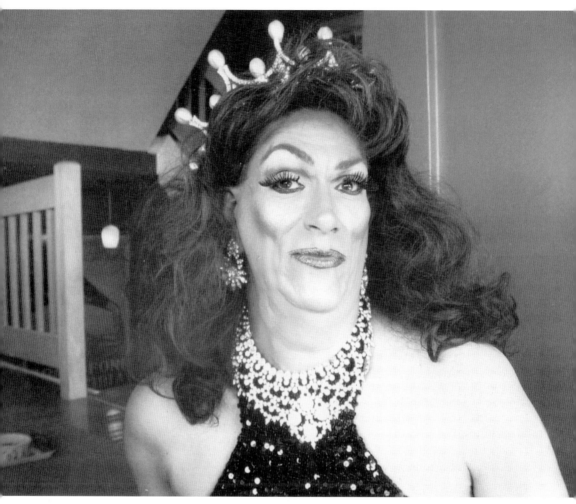

Queen Gigi (1953–)

Gary Gill, a prominent activist in Salem, works with causes relating to the LGBT community and animal protection, to name just a few. His alter ego as a female impersonator, Gigi, is deeply committed to the Over the Rainbow Club, which benefits the aging LGBT community, a formerly marginalized population. Gill has said, "This is about the community that I love and respect, that are with me." Also honored as Lady Gigi and Marquessa Gigi, Gill was inducted into the Imperial Court of Massachusetts for his untiring work and has received numerous awards for charity events and fundraising. He coordinated Salem's first Gay Pride Parade, hosts the Halloween Happenings Parade, and is active in World AIDS Conferences. A French filmmaker plans to follow Gigi for a year, chronicling his everyday life and activities throughout Salem and the United States. (Courtesy of Gary Gill.)

John V. Goff (1957–)

Goff is an architect and historic preservationist whose accomplishments reflect what Salem means to him and what he means to Salem. Among his numerous achievements are his commitment to restoring the John Bertram House on Salem Common, Old Town Hall, the Nathaniel Bowditch House, and Pickering House. He cofounded Salem Preservation Inc. to help restore Pioneer Village and has authored more than 200 "Preservation Perspective" columns for the *Salem Gazette*. Goff is a recipient of the prestigious Hawthorne Historic Preservation Award and has served as executive director of Historic Salem Inc., working on the Bicentennial of Nathaniel Bowditch project. He founded and publishes the *Salem Preservationist Newsletter* and has written several books, most recently, *Salem's Witch House: A Touchstone to Antiquity.*

William Legault (1960–)
Born and raised in Salem, "Bald Bil" has worked as a local reporter, bartender at The Lobster Shanty, fundraiser for the YMCA, and newly elected councilor-at-large for the city of Salem. While currently immersed in civic issues, he still advocates for various benefits, having raised more than $40,000 in just a few years. Legault is hard at work advocating and supporting Salem's affairs.

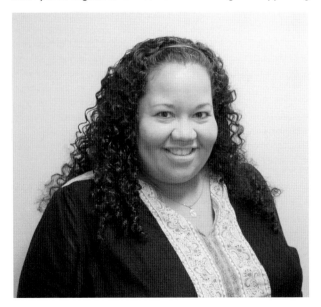

Lucy Corchado (1968–)
A Salemite from the city's Point district, Corchado considers herself lucky: "I'm a product of the Point and recognize all that is great about it." She believes that her upbringing in the neighborhood has guided her work as an advocate. President of the Point Neighborhood Association, board member of the North Shore Community Development Corporation, and city councilor from 2003 to 2007, Corchado has won numerous awards, including The Giving Tree and the MLK Leadership Awards. (Courtesy of Lucy Corchado.)

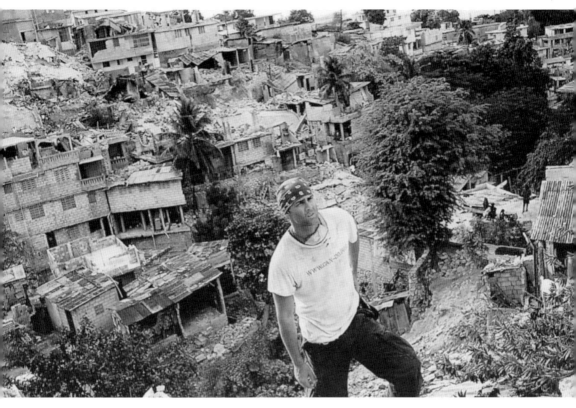

Erik Klein (1969–)

Salem still produces world-class humanitarians, and among the most notable is Erik Klein. While at Florida Atlantic College, Klein volunteered in the relief efforts for Hurricane Andrew. After graduating with a communications degree, he moved to New York, where he worked for several years until a combination of events drew him back to relief work. Witnessing firsthand the relief efforts for 9/11 and seeing footage of supplies stacked on docks and at airports while people suffered around the world, Erik, like many others, could not understand why relief could not be streamlined and hastened.

In 2004, while in rehabilitation from a car accident, Klein watched reports about the Sri Lanka tsunami. There appeared to be no lack of donations, but nothing much was happening on the ground. Taking $10,000 from his accident settlement, Klein set out to prove that things could be different. He went to Sri Lanka for what he thought would be a 10-day demonstration project, where he could videotape what his money was used for. But he ended up staying four months and spending most of his own money. Returning home, he started a charitable organization called Can-Do (Compassion into Action Network—Direct Outcome Organization). When Hurricane Katrina struck, Can-Do responded almost immediately.

This charity provides direct relief in disaster areas while offering donors the opportunity to see exactly what is being done through video, photographs, and virtual volunteering on its website. The goal is zero red tape. A review of Can-Do's website shows they are succeeding, through partnering with other organizations and local groups that are committed to rapid response. Erik's passion for "getting it done" is evident throughout the organization.

Can-Do has been singled out by world leaders and the United Nations for its work from Sri Lanka to Haiti. The organization is currently hard at work helping victims rebuild after Hurricane Sandy.

As Can-Do continues to grow and receive the attention it rightly deserves, it is starting new initiatives that involve utilizing veterans already trained as rapid responders to work in disaster areas. This exciting development will hopefully be available for deployment in the near future, whether to the New Jersey shore or Rwandan villages. (Courtesy of Can-Do Inc.)

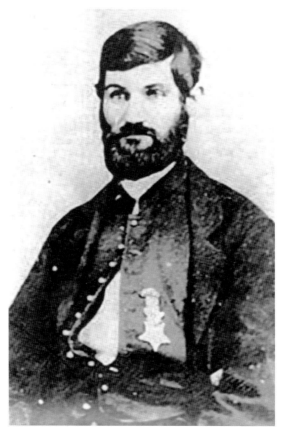

Robert Buffum (1828–1871)
Buffum was born in Salem into an active abolitionist family. In 1861, he enlisted in the Union Army's 21st Ohio Regiment and volunteered to join a raid led by Andrews, a civilian scout. The 22 volunteers were to commandeer a train and drive between Chattanooga and Atlanta while cutting telegram lines, burning bridges, and disrupting train travel. By doing so, it was hoped that Chattanooga would be unable to get reinforcements and would then surrender to the Northern Army. The risk of this daring raid was that, if captured, the men would be tried and executed as spies. Shortly after the raid began, the Confederate army learned of it and a chase and running gun battle ensued that would later be called the Great Locomotive Chase. After fighting their way to within 20 miles of Chattanooga, the men were captured. While the raid was unsuccessful in burning the bridges, due to heavy rains soaking the wooden structures, it successfully drew thousands of Confederate troops away from battle to protect vital railroads. This raid was immortalized in the 1956 Disney film *The Great Locomotive Chase*, in which the Robert Buffum character is highlighted. Of the volunteers, eight were tried and hanged as spies, another eight managed to escape back to Union lines, and the remaining six were spared from hanging through a prisoner exchange. Robert Buffum was among the group captured and exchanged in 1863. He was the third man to receive the Medal of Honor in the first Congressional Medal of Honor ceremony. After release from the Army, he had a difficult time and ended up spending three years in a mental hospital. His ailments were probably a result of his treatment while a prisoner. The seeds of tragedy were planted in his heroism. Following his release from the hospital, Buffum suffered from alcoholism. In New York, he shot and killed a man who was vilifying Lincoln. Buffum was convicted and sentenced to the Asylum for the Criminally Insane at Auburn, New York. In 1871, while still incarcerated, he committed suicide and was buried in an unmarked grave on the property. In 1995, the Congressional Medal of Honor Society placed a plaque on his grave. (Courtesy of Find A Grave.)

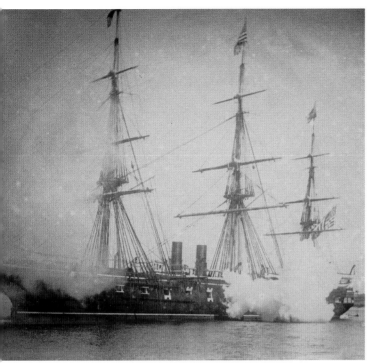

Thomas Lyons (1838–1904)

Lyons was born in Salem. His citation for the Medal of Honor read that he "served as seaman on board the USS *Pensacola* in the attack on Forts Jackson and St. Philip, on April 24, 1862. Carrying out his duties throughout the din and roar of battle, Lyons never once faltered in his brave performance. Lashed outside of that vessel, on the port-sheet chain, with the lead in hand to lead the ship past the forts, Lyons never flinched, although under a heavy fire from the forts and rebel gunboats." After leaving the Navy, little is known of the remainder of Lyons's life. (Courtesy of LOCPPD.)

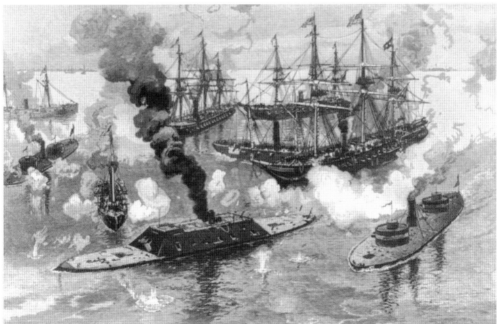

Thomas Atkinson (1824–?)

Born and raised in Salem, Atkinson joined the Union Navy at the age of 18. His Medal of Honor citation commended Atkinson for his coolness under fire in supplying rifle ammunition in the action at Mobile Bay in August 1864. It was this courage that brought his contribution to the notice of his fellow sailors. Little is known about Atkinson after he left the Navy. (Courtesy of LOCPPD.)

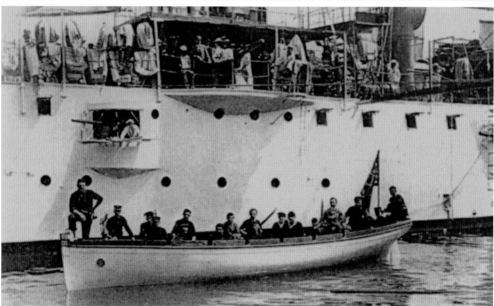

John Riley (1877–1950)
John enlisted in the Navy from Salem and saw action during the Spanish-American War. Most notable was his role in the Battle of Cienfuegos, where he volunteered on a dangerous mission to cut a communications cable. He was given the Medal of Honor for courage under heavy fire. After discharge, Riley returned to Salem, raised a family, and worked for the city until 1944. Riley Plaza was named in his honor in June 1959. (Courtesy of Naval History & Heritage Command.)

Samuel Bowden (1846–?) (OPPOSITE PAGE)
Bowden was born in Salem and earned the Medal of Honor while serving in the 6th US Cavalry with the Union Army. In response to raids on settlers, a force of cavalrymen went in pursuit of the raiders. They battled fiercely at the Little Wichita River. Corporal Bowden was awarded the Medal of Honor for "Gallantry during the pursuit and fight with Indians." Details of his later life are not known. (Courtesy of LOCPPD.)

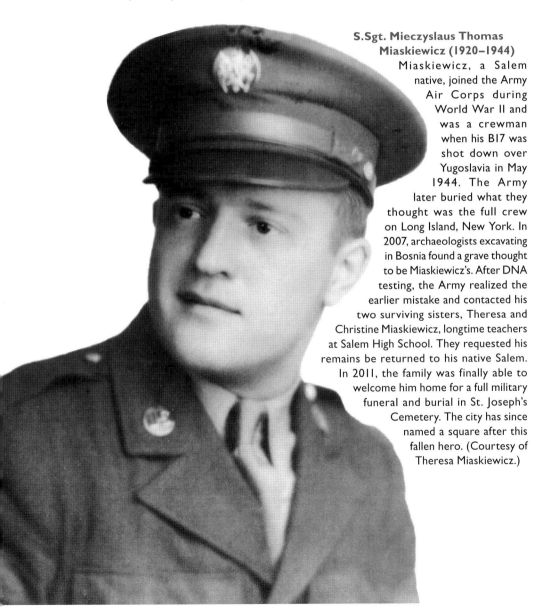

S.Sgt. Mieczyslaus Thomas Miaskiewicz (1920–1944)
Miaskiewicz, a Salem native, joined the Army Air Corps during World War II and was a crewman when his B17 was shot down over Yugoslavia in May 1944. The Army later buried what they thought was the full crew on Long Island, New York. In 2007, archaeologists excavating in Bosnia found a grave thought to be Miaskiewicz's. After DNA testing, the Army realized the earlier mistake and contacted his two surviving sisters, Theresa and Christine Miaskiewicz, longtime teachers at Salem High School. They requested his remains be returned to his native Salem. In 2011, the family was finally able to welcome him home for a full military funeral and burial in St. Joseph's Cemetery. The city has since named a square after this fallen hero. (Courtesy of Theresa Miaskiewicz.)

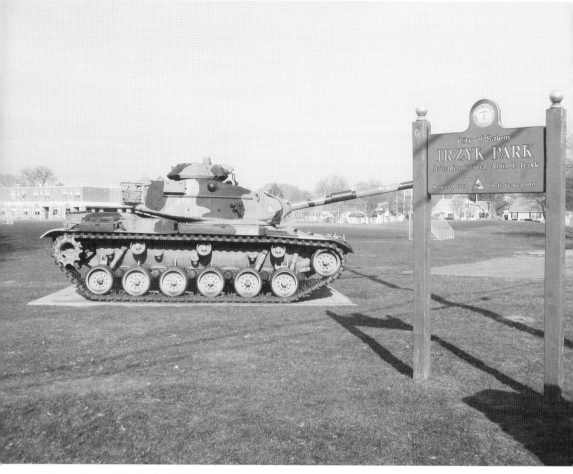

Brig. Gen. Albin Irzyk (1917–)

Irzyk grew up on Derby Street, not far from a park that was dedicated to him in 1999 for his extraordinary Army career of 31 years. After graduating from Salem High School in 1934, he went to the University of Massachusetts, where he was a leader in sports and academics. He was a member of ROTC and worked during vacations at Dan Donahue's store in Salem. At graduation, he was assigned to the 4th Armored Division. He participated as a tank commander in a number of major battles and was wounded twice in combat. Irzyk received the Distinguished Service Cross for heroism. He commanded forces during the Berlin Crisis in 1961 and served two years in Vietnam with the 4th Infantry Division. Irzyk retired as a general, commanding Fort Devens, Massachusetts. He has written extensively about his wartime experiences.

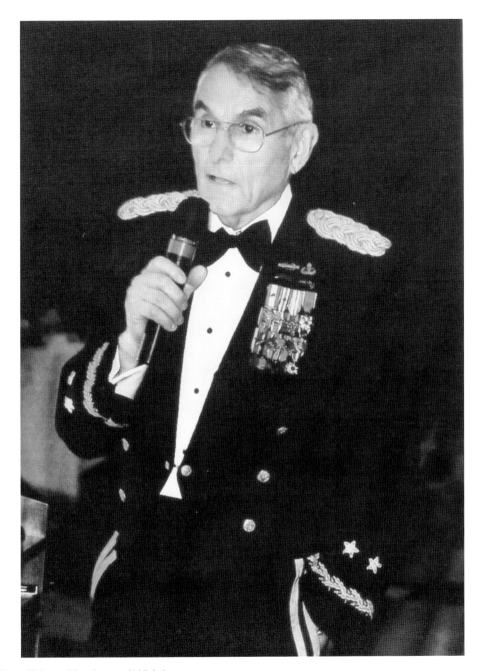

Gen. Sidney Shachnow (1934–)
At age seven, Shachnow was incarcerated in a Nazi labor camp in his native Lithuania. After suffering near-starvation and beatings for four years, he was reunited with his parents, then immigrated to the United States. Educated in Salem (it was the first time he had attended school), he joined the Army and applied for Officer Candidate School. A decorated hero of Vietnam, Shachnow was awarded 14 military honors, including two Silver Stars, a Purple Heart, and three Bronze Stars with V for Valor. Sid Shachnow earned the rank of major general after 40 years in service to this country, and he has penned a poignant memoir, *Hope and Honor*. (Courtesy of Creative Commons.)

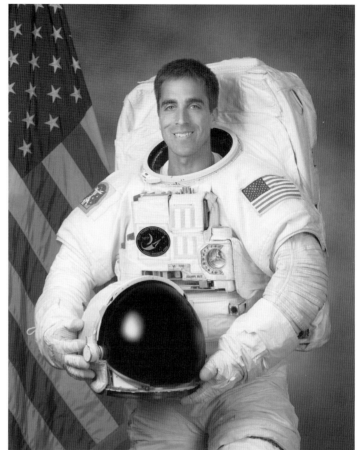

Chris Cassidy (1970–) Born in Salem, Cassidy graduated from the US Naval Academy and MIT. He was a Navy SEAL and is currently a NASA engineer/astronaut. He served in Afghanistan, earning the Presidential Citation Award plus two Bronze Stars. He spent 376 hours in space and joined an International Space Station crew in March 2013. Following his 2009 maiden space mission, when asked if he had earned anything as the 500th human in space, Commander Cassidy replied that his crewmates congratulated him with a Laurel and Hardy handshake. (Courtesy of NASA.)

Sgt. James Ayube II (1985–2010)
Ayube was Salem's first war casualty of Afghanistan. He joined the Army in 2007 and trained as a medic. Still sorely missed, he was dedicated to everyone. His compassion was exemplary, whether helping Afghan children in a free clinic or bonding with his wife, Lauren, siblings Alexander and Ashleigh, or his parents. Salem designated the Sgt. James Ayube II Memorial Drive in his honor. (Courtesy of the Ayube family.)

CHAPTER FIVE

Business

The successful person makes a habit of doing what the failing person doesn't like to do.
—Thomas Edison

What would you attempt to do if you knew you would not fail?
—Robert Schuller

The commercial history of Salem is one of ingenuity and risk-taking. Its early days of fishing quickly morphed into risky coastal trading, with small boats in the stormy Atlantic opening trade routes to Europe and the West Indies. As the population grew, so did commerce. With an entrepreneurial spirit, shipbuilding, tanning, building trades, and many other industries commenced.

When the revolutionary spirit rose up, it was Salem fishermen and traders who armed their boats, making them privateers. With most coastal ports under siege, Salem boldly took the lead. Armed with Letters of Marque, giving them authority to go after enemy ships, Salem mariners captured almost 500 British ships, setting the stage for Salem's greatest commercial enterprise.

When the Revolutionary War ended, Salem's merchants found themselves with large ships suitable for more distant trade. Often chancing everything, they sent these ships out to trade. Salem's sea captains, many in their early 20s, opened trade with unknown ports. Elias Derby led the way, sending his ships to open trade with India and China. Derby amassed a fortune and is reported to have been America's first millionaire. Others followed, effectively opening trade throughout the world. Salem ships were so numerous and were spotted at so many ports, whether in Zanzibar, Calcutta, or Canton, that natives would inquire about the "country" of Salem. Salem's iron men on wooden ships transformed the city into a hub of international trade. In the process, traders and captains became merchant princes.

While their wealth was great, these entrepreneurs were also dedicated to Salem. In addition to building architectural treasures that still survive, they funded a variety of charitable activities and organizations and were often elected to political office.

As the maritime heyday faded, Salemites like Stephen Phillips and Nathaniel Griffin saw the future in the industrialization of America. Salem remained a center of commerce for decades, thanks to its adaptation to industry. During the early 20th century, many of the small businesses highlighted in this book adapted and grew, becoming a stable force during the hard times of corporate mergers and foreign production.

Throughout its history, Salem has spawned great companies, such as Parker Brothers, Daniel Low's, and Almy's, only to see them fade away. However, while some of the old ones are gone, there are many new entrepreneurs ready to take a chance on Salem, put down roots, and become involved in the life of the city.

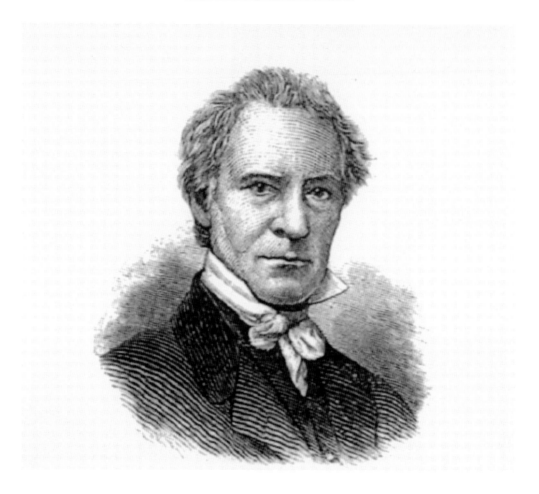

Joseph Dixon (1799–1869)

Born in Marblehead, Dixon was the son of a mariner. Despite having little formal education, Dixon had a variety of interests. In his teens, he invented a machine for making and cutting files, which had previously been handmade. As a young man, he became a printer. Unable to afford metal type, he taught himself to carve wood for type. Fascinated with the mineral graphite that was used as ballast on ships, Dixon studied metallurgy. From his self-studies, he invented crucibles for melting metals at high temperatures. In 1827, he opened a crucible factory in Salem. He also invented a machine for making pencils that combined graphite with clay and encased the "lead" in wooden holders. He also developed a stove polish from graphite. Not having a distribution network, Dixon sold his pencils door to door in Salem and other cities. They were not a popular item in the 1840s, but his crucibles were much in demand for the production of metals. In 1848, he moved his factory to New Jersey and, for a number of years, had a monopoly on crucible production. As a result, Dixon became very wealthy. His crucibles were the only ones capable of producing new steel metal. Throughout this time, he continued to improve and produce pencils as well as other inventions. Dixon, showing his broad interests, invented the mirror system for single lens reflex cameras and a new chemical-color lithography that allowed the US Mint to hamper counterfeit currency; produced gold and silver melting crucibles; worked on the development of Babbitt metal; and assisted Robert Fulton with his steam engine.

Surprisingly, most of Dixon's inventions and production faded over time, yet the pencil shot to fame after the Civil War. Production grew into the millions and made Dixon Ticonderoga a household name. The product was the most popular pencil in the late 19th and early 20th centuries.

Souvenir spoons, ca. 1890, sold by Daniel Low & Co. of Salem. The spoon with the gold bowl was called an orange spoon.

Daniel Low (1842–1911)

Low started his jewelry store on the first floor of historic First Church in 1874. In 1890, his son Seth (1867–1939) traveled to Europe, where he saw trade in commemorative spoons. Upon his return, he commissioned a "Witch spoon" and advertised it, setting off a national fad for commemorative spoons. His trademarked Salem Witch later came to symbolize the town. Daniel Low died at the store in 1911. The store closed in 1994. (Courtesy of Kirk Williamson.)

James F. Almy (1833–1899)

In 1858, Almy opened a store at 156 Essex Street. The story goes that when Almy needed money to expand, he went to Lurana Bigelow, who ran a nearby millinery shop. They fell in love and were married. In the 1880s, new partners were added, and the name was set as Almy, Bigelow & Washburn. It closed in 1985. James Almy was the first president of the Salem Board of Trade, a school board member, councilor, and state representative.

George S. Parker (1866–1952)

At 16, Parker invented his first game, Banking, and started the George S. Parker Game Company. From this beginning, his company grew. Partnering with his brothers, Charles and Edward, the company was renamed Parker Brothers. Rather than follow the norm of using games to teach morals, George felt that games just needed to be fun and interesting. Many of his games were topical, such as Klondike, based on the Alaskan Gold Rush. In 1906, he gained great success with the card game Rook. In 1935, the game Monopoly was an instant success, saving the company during the Depression. The firm's success grew with games such as Sorry, Clue, and Risk—all made in Salem. Parker Brothers was bought by General Mills in 1968. After a number of mergers, the plant in Salem closed in 1991.

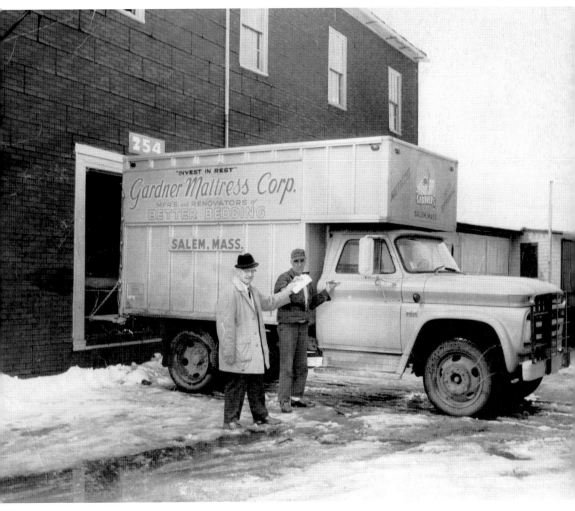

Alan Gardner (1907–1994)

During the Great Depression, Alan Gardner began his Gardner Mattress Corporation. Gardner felt that hard work, quality products, and customer service would make the difference. His talent and charm proved to be a winning combination, and the company grew and prospered over the decades. His factory on Canal Street soon became a supplier to hotels, colleges, and famous people. Always deeply involved in the community, Gardner supported and sponsored youth sports in Salem and the North Shore. A 32nd Degree Mason, he was involved in much of the organization's charitable activities. Even at an advanced age, he was present in the showroom to greet and help customers. The Gardner Corporation is currently run by his grandson, Gardner Fisk, who continues his grandfather's legacy. (Courtesy of Gardner Fisk.)

Dan Mackey (1928–2012)

As general manager of Thomas Mackey & Sons Contracting, Mackey (pictured at left with his twin brother, Herb) fixed every water drain and sewer in Salem. Working with his twin brother, Herb Mackey (whose scrap-iron sculptures are on Blaney Street), Dan was more than a go-to person around town. He was a can-do person who knew every inch of Salem's streets. His positive attitude was contagious, as when the company's employees had to work in foul, rank sewers. He cajoled his coworkers to "just make a pleasure out of it!" In his final days, he worked hard for the rededication of the World War II Memorial at Salem State University. Mackey was a no-nonsense guy who was all about problem solving, whether it was Salem's sewers and drains or someone's breaking heart. His compassion was endless, and when someone became his friend, they were his friend for life. (Courtesy of the Mackey family.)

Herb Mackey (1928–)

A surprise awaits people en route to catching the Salem Ferry to Boston, when they pass an outdoor exhibit on Blaney Street. The hair-raising yet amusing iron creatures are the idiosyncratic and eye-popping sculptures of Herb Mackey. Working in the family business, Thomas Mackey Contracting, with his twin brother, Dan, Herb did everything from welding to excavating. From those job skills—along with the fact that he throws absolutely nothing away—he concocts everything from arachnids and gargoyle-type creatures to benign beasties out of the salvaged scrap iron. So iconic is his outdoor display that producer Chad Carlberg filmed an intimate YouTube documentary of Mackey and his craft, *One Man's Trash*. When asked about his avocation, Mackey, with his humble manner, his Irish wit, and a playful wink, responds, "It's been a great ride."

Lee Delande McMath (1954–)

With her extended family, Lee Delande McMath (right) still runs Delande's Lighting. Five generations after its founding, the business is nearing its centennial. It began with Ovila Delande and his son, Arthur, converting gas lighting fixtures to electric ones and selling functional and elegant lighting to Salem residents. To this day, Delande's has lit up the stately residences of the McIntire District, churches, restaurants, art galleries, and countless homes throughout Salem and the North Shore. Delande's has even supplied chandeliers, lamps, and accessories as props for a recent Adam Sandler film located in and around Salem. The current generation, run by Lee's siblings, Susan Powell (left), David Delande, and Richard Delande, has upheld their great-grandfather's vision. The Delande family still values the mom-and-pop sensibility and continues to provide personal assistance and design skills to their customers.

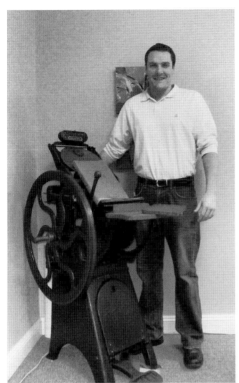

Henry (1952–) and Luke Deschamps (1986–)

The Deschamps family of Dechamps Printing is proud of their company's impending centennial in 2016. Started by Henry and Paul Deschamps during World War I, the firm prospered with printing and typesetting for Salem businesses. During the Great Depression, Deschamps Printing acquired government contracts, enabling it to stay afloat. It now provides services to corporations in Salem and nationwide. Here, Luke Deschamps poses next to his grandfather's 1920s Pearl Handpress.

E.W. "Buddy" Hobbs (1920–2008)

Buddy Hobbs spent most of his working life running the iconic Willows eatery, founded by his great-grandfather in 1892. It was here that the first ice-cream cones were served in New England in 1904. Buddy Hobbs oversaw the staff that became part of his extended family and did much to keep the Willows vibrant. Fifth-generation family members Charles and Priscilla Hobbs now manage the establishment, the place in Salem to go for popcorn and ice cream. (Courtesy of the Hobbs family.)

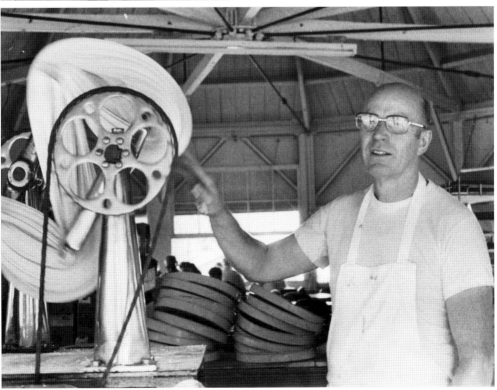

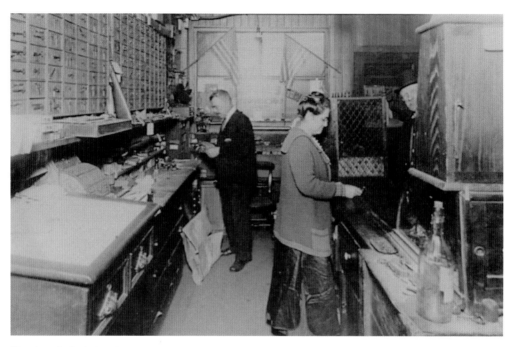

Hayden Safe & Lock

Hayden Safe & Lock, a company that started in 1910, is today operated by the Whitmarsh brothers. Their grandfather, John Whitmarsh, bought it from the original Hayden family in the 1950s. The company began by sharpening blades and making locks and safes. Today, using the latest technology, it outfits the oldest locks in the country, from skeleton and bit keys to leading-edge mechanisms made today. (Courtesy of John and Matthew Whitmarsh.)

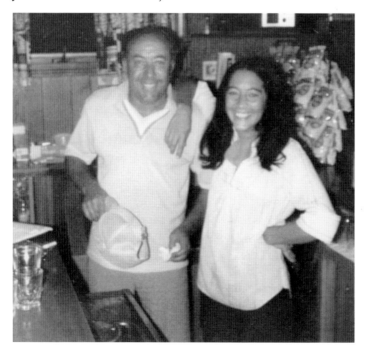

Lionel "Beaver" Pelletier (1928–2010)

Lionel Pelletier (left) ran Dube's Seafood Restaurant for many years, and his family operates it to this day. "Beaver" Pelletier was a successful businessman and an accomplished sportsman, yet he may be best remembered for his big heart and the freshest seafood in town. To this day, his daughter, Mary Pelletier (right), ensures Dube's is still the place to go in Salem for the freshest seafood. (Courtesy of Mary Pelletier.)

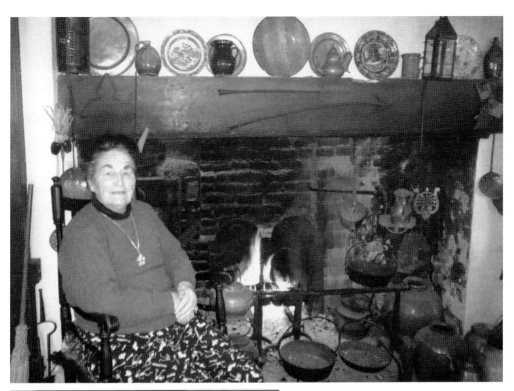

Kay Gill (1931–)

Gill has owned and operated The Stephen Daniels House since 1962. It is one of the oldest houses in Salem, having been built in 1667. Still a private home, it has operated as a bed-and-breakfast for nearly a century. Gill, who recently celebrated 50 years as innkeeper, reveres its authenticity. Despite its up-to-date amenities, this home, nearing four centuries old, never loses its ability to transport guests from the present day to long, long ago. (Courtesy of Robin McDonald.)

Mike Allen (1953–)

In 1980, Red Lion Smoke Shop began selling smokes, magazines, comic books, and baseball cards, and today offers a huge selection of pipes and cigars. A longtime Salem resident, Allen wrote a cigar column for *Quarterly View of Wine*. He is a past president of the Salem Chamber of Commerce, a former school committee member, is active in fundraising, and is a panelist on a political talk show on SATV.

Tim (1961–) and Shaun Clarke (1964–)

Together, these brothers operate Waters & Brown, which began in 1895 as a hardware store established by Henry Waters and J. Clarke Brown. It had a reputation for quality products, customer service, and home delivery. The photograph to the left shows brothers Donald (left) and Edward Clarke, who bought the business in 1969 and relocated it to its present location. Their sons, Tim and Shaun, have navigated the old firm into the 21st century, evolving from its utilitarian foundation into the field of home decor. In the 1980s, the company offered paint, wall coverings, and, later, window treatments and upholstery. Waters & Brown has changed with the times and improved by keeping up with trends and the culture in Salem. Progress with old-world values is still its trademark. Pictured below is a Waters & Brown delivery wagon around 1914. (Both courtesy of the Clarke family.)

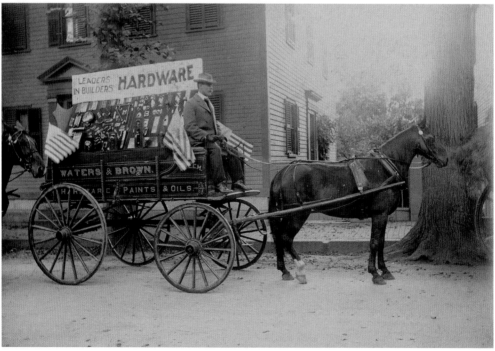

John A. Bertini (1945–)

John Bertini fondly remembers his grandfather, Frank Bertini, who arrived on these shores from Palermo, Sicily, in 1915. How Frank Bertini and three ensuing generations established and operated Bertini's Restaurant is a story of perseverance in a brand-new country. Frank started with grocery stores on North Main Street (below). His son Charles was born in 1912, and when he was old enough to participate in the business, they opened Bertini's Restaurant, in the same building since 1943. Charles and his wife, Esther, with numerous family members, were the sole chefs for years. The current owner, John A. Bertini (right), and his wife, Polly (center), developed the business even further. Today, their son John (left) has joined this longstanding family enterprise that for four generations has fed hungry Salemites its signature pizza and wholesome Italian fare.

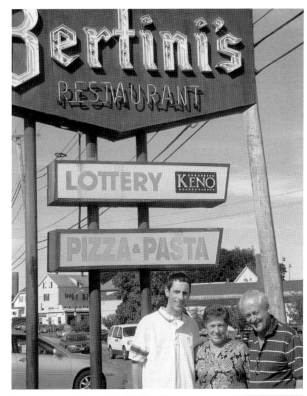

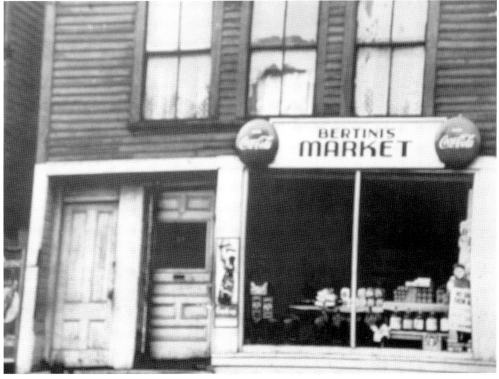

Richard Gagnon (1955–)

Another multigenerational Salem business, Gagnon Shoe Repair was founded by Peter Gagnon at the end of World War II. As it approaches its 67th year, Peter's son Rich (shown here) runs the business. He began working at the age of seven in his father's shoe repair shop, sweeping floors, pulling heels, and cementing soles. Years later, a course in orthopedics helped Rich with techniques for molding shoes for people with foot deformities and problems related to diabetes.

Giovanni (1948–) and Paula Graziani (1956–)

Caffé Graziani opened 22 years ago. It is much more than a local, family-friendly eating place. The owners have been involved with the Salem community in myriad ways, from hosting wine tastings and historically inspired feasts to coordinating trips to Chef Giovanni's hometown in Italy for cooking demonstrations and classes. The Grazianis have a clientele made up of regulars as well as tourists who enjoy their Italian specialties.

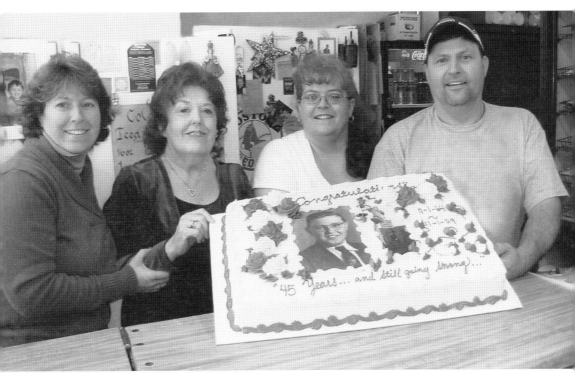

Zigmunt "Ziggy" Akatyszewski (1933–1983)

Ziggy Akatyszewski started his business with his wife, Alice (second from left), almost 50 years ago, and it is still going strong. In 2014, Ziggy's Donut Shop will enjoy a half-century of service to Salem's donut and pastry lovers. John (right) began helping his father stir muffin batter at age eight, and is still there every morning at 2:00, making hand-cut donuts, muffins, and pastries. When Ziggy passed away, Alice kept the business going, and their donuts and pastries continued to bring in the old-timers like Pep Cornacchio, the Mackey twins, and Red Sox legend Johnny Pesky. Alice, her children, John, Patty (second from right), Carol (left), grandson Jonathan, and in-laws, have worked there and have opened a second Ziggy's in nearby Peabody. They strive to keep Ziggy's a neighborly place and to honor their father's memory. (Courtesy of the Akatyszewski family.)

Neil Chayet, Esquire (1939–)

Chayet is one of Salem's busiest professionals. He balances a love of law, psychiatry, broadcasting, and historic preservation. Chayet served on the task force for the Boston Strangler investigations and drafted the first community mental health law in the United States. Owner of Chayet Communications, he is on several civic and academic boards.

"Going green," he now lives in one of Salem's most historic houses, which he and his wife, Martha, have flawlessly and environmentally restored. The Joseph Story House was in deplorable condition, but is now one of Salem's most elegant homes and is listed in the National Register of Historic Places. Their environmentally sound yet historically accurate home boasts a generous energy rating for sustainable buildings. Attorney Chayet has hosted, since 1976, a talk show, *Looking at the Law*, on Boston's WBZ-CBS radio and television stations. (Courtesy of Roberta Chadis.)

Jay Collins (1953–)

In this photograph, Collins stands beneath a painting of vintage vehicles by Salem artist John Hutchinson. Collins and his business partner, Ralph Schiavone, own North Shore Auto Clinic (established in 1928). They have expertly maintained and repaired automobiles for 37 years at this location, the site of the old, iconic Texaco Garage. Salemites know that when this shop fixes a car, it stays fixed. Collins and Schiavone, enthusiasts of the vintage, sporty style, also work on restoring classic cars, including the "woodies" of the 1960s.

Ted (1954) and Frank Monroe (1947)

The Monroe brothers, Ted (right) and Frank, opened Derby Square Bookstore in 1975. This quirky shop has books stacked from floor to ceiling—literally—and in row upon row. There is scarcely an inch to move. Beat-up shelving bolsters first editions, paperbacks, science fiction sagas, and romance novels. A tourist mecca, this jam-packed confluence of books serves to lend more credence to its eccentric literary mood. "It's all about the books here!"

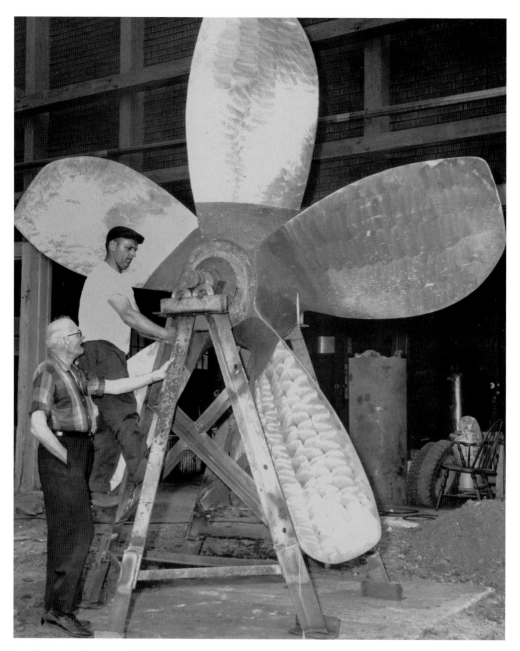

John Pelletier (1967–)

H&H Propeller Shop has been in the same location since 1940. Run by John Pelletier, it is still under the ownership of the Pelletier and Martin clans, whose 31 employees are considered family, because this is indeed a family- and community-oriented business. Specializing in refitting everything from tugboats to fishing fleets to yachts, its customer base has included the US Coast Guard, New York City Fire Department, singer Billy Joel, FDR's presidential yacht, and Adm. Richard E. Byrd's expedition vessel. Involved in charity work for Wounded Warriors and Salem's K-9 police dogs, Pelletier's staff also stays busy during the city's Annual Walk for Cancer, serving water, opening up their rest rooms, and broadcasting upbeat music to champion the walkers during this popular annual event. (Courtesy of John Pelletier.)

CHAPTER SIX

Entertainment and Sports

The guy who was waving the flag
That began with the mystical hand,
Hip hooray! The American way
The world is a stage; the stage is a world of entertainment!

—Howard Dietz and Arthur Schwartz, *That's Entertainment*

Like most Americans, Salemites cannot seem to get enough entertainment in their lives. They love everything that happens in engaging spaces, from sports arenas to movie theaters to concert halls and the stage. They cheer, applaud, hurrah, and call out "bravo!" And why? Because sports and entertainment are satisfying; they fill the void at the end of a toiling workweek. Such diversions bring fresh air to one's morale.

Salem has been the home to so many who have or still do fill residents' souls or make them laugh or make their hearts swell to near bursting. It might be a Red Sox win, an Oscar-worthy performance, or a musical piece that makes listeners fairly swoon. It is all great fun and an entertaining escape from reality. Whether it is a rousing performance of the Paul Madore Chorale, the Salem Philharmonic, or Mamadou Diop's African fusion sound coming from Artists' Row; a basketball win by Salem High's Scoonie Penn, or the sweet memory of Pep Cornacchio rallying a team of young athletes; a stirring performance of Arthur Miller's *The Crucible*, or the jubilant sounds of a recording of Jean Missud's Salem Cadet Marching Band—these are the things that make Salemites smile, allow them to forget their tribulations, and inspire them to face and appreciate another day.

Jack Koen (1873–1934) and William Koen (1879–1928)

While running a grocery store on North Street, Jack Koen (top left) was moonlighting as a movie projectionist at the Willows in the 1890s. In 1906, he opened the Kozy Moving Picture House in Salem, then added another theater, the Comique. With demand for movies continuing to grow, his brother William Koen (top right), a former city engineer, became his business partner. Together, they expanded the Comique, bought another theater, and built the Federal Theatre (below) on Washington Street, a large, state-of-the-art theater complete with custom-made organ and orchestra. These theaters offered vaudeville shows as well as movies in the days before talkies. Over the next 20 years, the brothers purchased or built six movie theaters in Salem and elsewhere. Together, they were active in civic and religious organizations, organizing fundraisers, and charities.

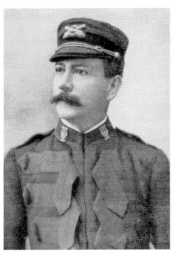
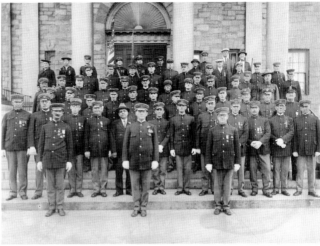

Jean Missud (1852–1941)
Though born in France, Missud has probably contributed more to Salem's musical heritage than any other resident and is still held in high regard. After he arrived on these shores, his talent led to organizing the prestigious 2nd Corps of Salem Cadets Band. An inspired marching-band leader, Missud also composed *Chilean Dance*, *Magnolia*, *Salem Assemblies Waltzes*, and *March of the Witches*. With 35-plus musicians, this esteemed military band traveled across America and to Canada and England.

Paul Madore (1936–)
With his chorale of 55 to 60 singers, Paul Madore has been making beautiful music in Salem for 40 years, having graced concert halls, churches, museums, and venues throughout the United States and Europe. Madore conducts everything from the classics to pops concerts to show tunes. The ensemble has recorded 10 CDs, toured Europe, and sung at the dedication of the World War II Museum in Normandy, France. (Courtesy of Paul Madore.)

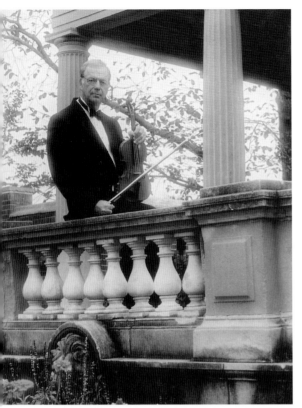

Alan Hawryluk (1942–)

After 46 years, Maestro Hawryluk still conducts Salem Philharmonic Orchestra and its 45 professional and semiprofessional musicians. He attended Eastman School of Music, then studied violin at New England Conservatory, and is a string faculty member at Gordon College. The free Salem Philharmonic concerts date from 1904 and end each season playing jointly with the Salem High School Symphony Orchestra in a moving, adult-and-teen rendition of a classic favorite. (Courtesy of Alan Hawryluk.)

Philip Wolen (1877–1937)

Wolen emigrated from Poland in 1900, settled in Salem, and lived at 13 Essex Street in his last years. As a youth, hard work enabled him to set up shop making violins, and his role as a luthier brought him fame. His instruments are still sought after today. He hand-carved more than 300 violins and was a master bow maker. His virtuosity still resonates in the beauty, quality, and tonality of his instruments. (Courtesy of John Davis.)

Dick Elliott (1886–1961)
Born in Salem, Elliott pursued a successful acting career with stock companies, landing on Broadway in the 1920s. He then acted in movies. Never a leading man but always recognizable, he went from movies to television, landing many notable roles. He is most remembered as Mayor Pike of Mayberry in *The Andy Griffith Show*. He had over 363 roles in movies and television. (Courtesy of Creative Commons.)

John Larch (1914–2005)
Actor John Larch was born in Salem and tried various occupations. Following a stint in professional baseball, he worked in radio, playing *Captain Starr of Space* in 1953. He then went to Hollywood, where he became a character actor in 34 film roles and 128 television roles. He was recognizable in *The Twilight Zone, Gunsmoke, Dallas*, and *Dynasty*. A good friend of Clint Eastwood, he often had a role in his movies, most notably as the police chief in *Dirty Harry*. (Courtesy of John "J-Cat" Griffith.)

Al Ruscio (1924–)
Ruscio was born and educated in Salem, graduating from Salem High School. He began his theatrical career after his World War II service in the Army Air Corps. He was in college when he was cast in *13 Rue Madeleine*, marking the beginning of a 65-year career on stage (*The Country Girl, A View From The Bridge, King Lear*); in film (*Al Capone, Any Which Way You Can, Godfather III, Guilty by Suspicion*); and in television, where he became one of Hollywood's busiest character actors, racking up hundreds of appearances. The list virtually spans television history. Beginning in live television, he appeared in *The Untouchables, Have Gun–Will Travel, Bonanza, The Rockford Files, Barney Miller, Lou Grant, St. Elsewhere, Hill Street Blues, Seinfeld, Tracey Takes On, The X-Files,* and *Life Goes On.* He is a veteran acting teacher as well, and his book *So Therefore . . . A Practical Guide For Actors* was published in 2012. (Courtesy of Judy Fox.)

Paul Van Ness (1951–)
A businessman and filmmaker, Van Ness cofounded CinemaSalem and the annual Salem Film Fest. He has produced documentaries chronicling the history and culture that epitomizes Salem; his most recent is *The Spirit of Salem*. A graduate of Gordon College, Van Ness started as an independent filmmaker before opening CinemaSalem. However, Hollywood mandated a modification in film development. As part of its decision to "go digital," the industry called for brand-new formatting in projecting its high-tech films. Lacking the $60,000 for the necessary equipment, loyal Salemites rose to the occasion and, within 12 days, during the Christmas season, in a threatening economy, raised the needed funds for Salem's theater to adapt to Hollywood's new standards. It was a fitting tribute to CinemaSalem as well as to the people of Salem, who helped save its intimate, local theater. (Courtesy of Paul Van Ness.)

Leo Jodoin (1952–)

A prominent figure in Salem, Jodoin hosts SATV's *Salem Now* and *On the Road with Salem Now*, and is actively involved in local issues. Over the course of 500-plus shows, which he does pro bono, Jodoin has kept Salem aware of what is happening, in his pull-no-punches style. He derives enjoyment from supporting Salemites; his greatest pride was when the legendary 2nd Corps of Salem Cadets made him an honorary member. (Courtesy of Leo Jodoin, SATV.)

Mamadou Diop (1954–)

Born in Sénégal and living in Salem, Diop has a distinctive style that can be heard along Artists' Row, the Willows, and all over the world. He has added a unique soundtrack to Salem life with his "hypnotic fusion of African and traditional music." He won Boston Music Award's International Artist of the Year, and he is known for humanitarian causes, specifically A3D Inc. for those still suffering in Sénégal. (Courtesy of Rick Ashley.)

Erik Rodenhiser (1967–)

Rodenhiser, born and bred in Salem, wanted to act from a very young age. He is known around town as the owner-operator of the Griffen Museum Theatre. His theater specializes in comedies, but also produces experimental musical events and interactive and children's programs. During Salem's Halloween season, his venue includes the popular Gallows Hill Museum Theatre, primarily for tourists, often followed by *A Christmas Carol* during the holidays. Rodenhiser does voice-overs and television commercials for local businesses. Many in the North Shore are familiar with his comedic commercials for i-Party during Halloween as well as numerous others. He recently played Sir Lancelot and other characters in *Spamalot* in Marblehead. His favorite roles are Fagin in *Oliver!* and the Scarecrow in *The Wizard of Oz*.

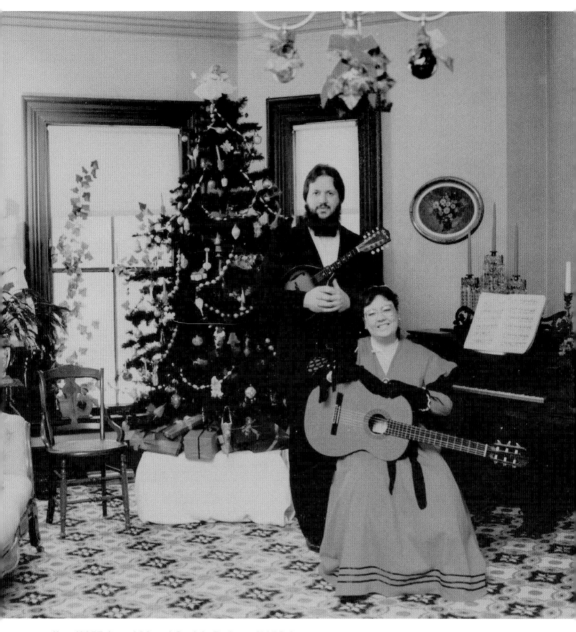

Jim (1957–) and Maggi Smith-Dalton (1956–)
Since the 1980s, this charming and entertaining husband-and-wife team has become well known for innovative, educational, and creative programming. They have been highly praised for their solid research and dazzling, spellbinding musical abilities. The Daltons, both of whom hold advanced degrees, specialize in performing 19th-century and early-20th-century American music in historically informed style and on period-appropriate instruments. Honored by several state arts agencies, they founded and direct Singing String Music, the American History and Music Project, and the Salem History Society. They have recorded four albums and published original compositions and historical/musical articles and books. The Daltons have performed nationwide, on commercial and public radio and television. (Photograph by Lang Photography; courtesy of Stowe-Day Foundation.)

Debra Crosby (1963–)
A mover and shaker around Salem, Crosby is the recipient of several media awards and founded Conquest Creative Media and A Quest Actors' Studio. She has been instrumental in Salem CultureFest and Salem Film Fest, and produced *The Talent Quest TV Show* for WBIN-TV. On the latter show, she introduced the great child soprano Jackie Evancho to broadcast commercial television. She is the daughter of the late Dave Maynard of radio and television, who inspired her to pursue a career in media for both entertainment and social causes. Through A3D Inc., she and musician Mamadou Diop are committed to African humanitarian projects and other local causes. (Courtesy of Kate Drew Miller.)

Larry Young (1964–) and Susanne Powers (1970–)
Young and Powers began MusicalPASTimes, collaborating on music of the 17th, 18th, and 19th centuries, bringing it to life in the 21st century. String instruments, violin, fiddle, viola, and cittern (16th-century guitar) fill listeners' contemporary ears with altogether antique and classic sounds. Arrayed in grand, 18th-century finery, collectively and individually, the couple has played throughout Salem, at Hamilton Hall and Peabody Essex Museum, Boston's Museum of Fine Arts, Faneuil Hall, for the Austrian, Russian, and Vatican Embassies, the Hamburg Symphony, and for Pres. Bill Clinton. Larry Young graduated from Dartmouth College and studied at Longy and Berklee Schools of Music. Dr. Susanne Powers was educated at Julliard and Catholic University of America and continues to teach violin throughout the North Shore and metro Boston. (Courtesy of Ken "Worm" Harris.)

Joe Cultrera (1958–)

A producer, director, editor, and writer, Cultrera's great accomplishments are his documentary filmmaking. The Salem native has a production company, Zingerplatz Pictures, and his work has been broadcast on network, cable, and public television. He directed and edited the award-winning *Hand of God* about child abuse within the clergy, broadcast on PBS; and *Witch City*, chronicling Salem's present-day incarnation, which he has called the "Disneyfication of American history in Salem." Cultrera has worked on documentaries by legendary director Michael Apted, and his own editing includes numerous programs for the Food Channel, Court TV, Nat Geo, and Discovery Channel. He has been the key figure in establishing the annual Salem Film Fest of independent and documentary films. The hardworking and peripatetic Cultrera still makes Salem his home. (Courtesy of Hugh Walsh.)

Kyle Cooper (1962–)

A movie fan from a young age, Salem native Cooper set his sights on the movie industry, becoming a leading film designer. With an MFA in graphic design from Yale School of Art, he has almost single-handedly revitalized the main-title sequence as an art form. Cooper sees the opening credits and title sequence as the film's prologue, thus setting the tone of what is to follow. Cooper has produced such memorable beginnings as the flipbook logo panel for the original *Spiderman* movie and his critically acclaimed sequence in the movie *Se7en*. He has created over 150 title sequences and founded two internationally recognized film design companies. A member of the Alliance Graphique Internationale, he has the honorary title of Royal Designer for Industry from the Royal Society of Arts in London. (Courtesy of Kyle Cooper.)

Dann (1964–) and Sara Maurno (1963–)
The Maurnos founded Salem GASworks (Guild of Artistic Sorts) because of an abundance of "artistic sorts" in Salem. The husband-and-wife team initiated a program for artists and musicians of every genre. Its earlier incarnation was along Artists' Row, with workshops promoting emerging artists, crafters, and musicians. By inviting them onto their SATV show, the Maurnos offered a platform for artistes to showcase their works. Dann Maurno is an actor, often performing for Salem Theatre Company. He is also a business writer and nonfiction author. Additionally, he is a leather crafter, fashioning bookbindings, costumes, and masks through his online studio Bootblack Leathers. Sara Maurno writes, including for her newly launched blog, *Saturday Socks*. She also creates interior design, acts in local theater, has taught acting in New York, Boston, and Salem, and owns the marketing firm Hey Sadie Mae! (Courtesy of the Maurnos.)

Steve Thomas (1952–)
The well-regarded handyman of the PBS series *This Old House* from 1989 to 2003, Thomas lived in Salem many years and painstakingly restored an 1860s home on Broad Street. He won a Daytime Emmy for hosting *This Old House* and has authored several books. Thomas still restores houses, appears on DIY shows, was active in Habitat for Humanity, and is a committed advocate for sustainable and green initiatives. (Courtesy of Ed Schipul.)

Arthur Miller (1915–2005)
In 1952, playwright Arthur Miller spent time in Salem, researching the witchcraft trials. He then wrote *The Crucible,* his play concerning paranoia and injustice. Miller compared 17th-century Salem to the McCarthy era: "The more I read into the Salem panic . . . below its concern with justice, the play evokes . . . fear of the supernatural and political manipulation." Miller singlehandedly lifted Salem out of American history books and put it on stages throughout the world. (Courtesy of Creative Commons.)

Julie Dougherty (1950–)
A Salem legend who began singing as a little girl, Julie Dougherty has graced many a stage in Salem, as well as in Nashville and Austin. She attended Salem schools and graduated from Salem State College. Immensely popular, Dougherty has made a living with her voice since 1973, recording several CDs. She was awarded the Salem Cultural Council Award for her daylong fundraiser for residents left homeless following the 2006 Danversport fire. (Courtesy of Dawn Kingston.)

Louis Trudel (1913–1971)
Born in Salem, Trudel moved as a youngster with his family to Edmonton, Canada. At age 20, he signed with the Chicago Blackhawks the year they won the Stanley Cup. Considered a courteous player, he was seldom in the penalty box. Trudel spent his post-NHL years playing with the minor leagues, coaching, and serving as a goal judge. (Courtesy of Paul Plecinoga, Salem Archives.)

Joseph A. "Pep" Cornacchio (1920–2010)

On a blistering day, hundreds of friends, acquaintances, old timers, teenagers, homeless people, and dignitaries braved the relentless heat outside the funeral home in Washington Square to say goodbye to a remarkable man. For all who knew him, Pep Cornacchio was *the* Ambassador of Good Will for the city of Salem. He was the most affable, lovable, and friendliest character Salem had produced in decades, perhaps even centuries. Beloved by everyone, stranger or Salemite, Pep was a rare gem; his good-natured disposition and constant smile were the sunshine on any given day and for anyone who ran into him. No one could turn a frown upside down in a heartbeat like Pep Cornacchio.

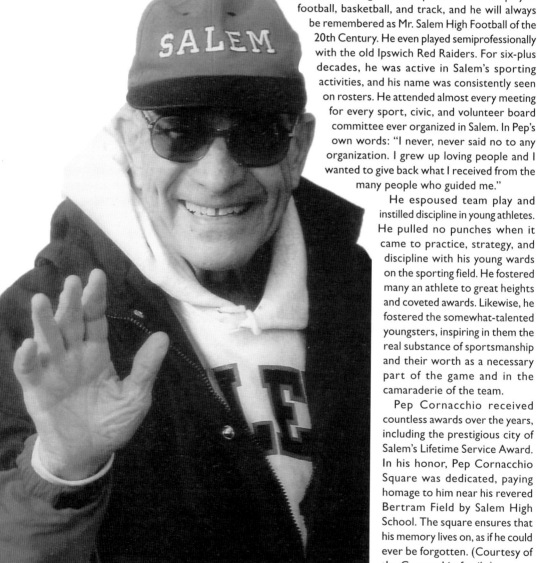

Born in Salem, Pep was an excellent athlete and made Salem High School proud when he played football, basketball, and track, and he will always be remembered as Mr. Salem High Football of the 20th Century. He even played semiprofessionally with the old Ipswich Red Raiders. For six-plus decades, he was active in Salem's sporting activities, and his name was consistently seen on rosters. He attended almost every meeting for every sport, civic, and volunteer board committee ever organized in Salem. In Pep's own words: "I never, never said no to any organization. I grew up loving people and I wanted to give back what I received from the many people who guided me."

He espoused team play and instilled discipline in young athletes. He pulled no punches when it came to practice, strategy, and discipline with his young wards on the sporting field. He fostered many an athlete to great heights and coveted awards. Likewise, he fostered the somewhat-talented youngsters, inspiring in them the real substance of sportsmanship and their worth as a necessary part of the game and in the camaraderie of the team.

Pep Cornacchio received countless awards over the years, including the prestigious city of Salem's Lifetime Service Award. In his honor, Pep Cornacchio Square was dedicated, paying homage to him near his revered Bertram Field by Salem High School. The square ensures that his memory lives on, as if he could ever be forgotten. (Courtesy of the Cornacchio family.)

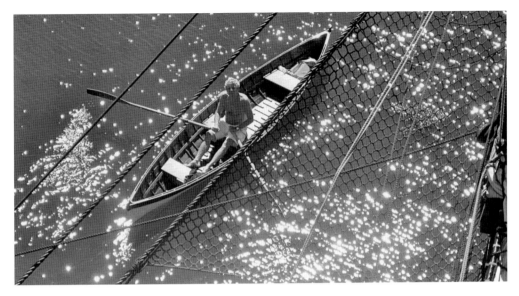

Eric Olson (1941–)

The owner of Salem Wine Imports and an avid sportsman, Olson has resided in Salem Willows for more than 30 years. An enthusiastic skier who has slalomed down Aspen, Stowe, and Sugarloaf, his sporting love has always been his boats. A well-rounded sailor, Olson found a new love when he was given a Swampscott Dory on the condition he repair and start rowing it—and he has, to the tune of 250 miles a year. Eventually, he hired a master boat builder to construct his dream, the Herreshoff-Gardner–designed dory with all the bells and whistles. Due for a shoulder replacement, Olson still won in his division in The Great Race, a single, fixed-seat event. His time was 1 hour, 46 minutes. He accomplished this despite the pain in his shoulder and just two weeks before his 70th birthday. Olson is a real Salem sportsman. (Courtesy of Eric Olson.)

Tom Thibodeau (1958–)

As a student, Thibodeau played basketball for Salem State University. In 1981, he became assistant coach of Salem State basketball. In 1984, he was named its head coach. The following year, he became assistant coach at Harvard, where he remained for four years. In 1989, he began his career in the NBA as an assistant coach for the Minnesota Timberwolves. Since working with the NBA, he has also been an assistant coach with the Spurs, the 76ers, the Knicks, the Rockets, and the Celtics from 2007 to 2010. In 2011, he was named head coach of the Chicago Bulls. That year, he was named Coach of the Year after tying the NBA record for wins by a rookie head coach. Thibodeau was a head coach for the NBA All-Star Game in 2012. (Courtesy of Chicago Bulls/Bill Smith.)

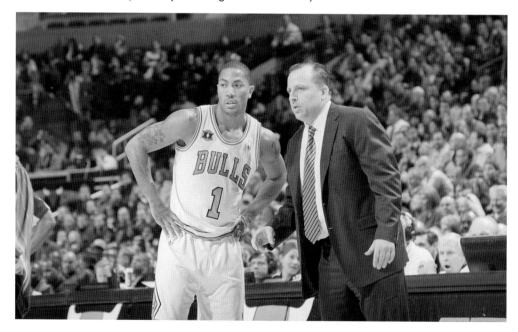

Bill McKenna (1933–2012)
Salem High School's golden boy of football, McKenna was also a powerhouse at Brandeis University. He played for Philadelphia and in the Canadian Football League. Innately athletic, he was often seen running by the railroad tracks in South Salem, up to the old tunnel, then running all the way back. McKenna was a gentle giant whose philosophy was, "You don't drink, you don't smoke, you train." (Courtesy of Paul Plecinoga, Salem Archives.)

Matt Geiger (1969–)
At seven feet tall, the Salem-born Geiger was destined to play basketball. He was recruited by Auburn University before transferring to Georgia Tech. In 1992, he was drafted by the NBA's Miami Heat. Playing center, Geiger was with Miami for three years before moving to the Charlotte Hornets, then finishing with the Philadelphia 76ers. Geiger averaged 9.2 points and 5.7 rebounds a game in his 10-year NBA career.

Jeff Juden (1971–)
One of the greatest pitchers in Massachusetts history, Juden led Salem High School to the state championships in 1989 and won the Gatorade Massachusetts Baseball Player of the Year Award. He began his professional career with the Houston Astros. At the time, he was the youngest player in the National League. His best season was 1997, when he pitched more than 161 innings for the Montreal Expos. He then pitched for the Cleveland Indians, compiling an 11-6 record with 136 strikeouts and a 4.46 ERA in one season. Juden also played for Philadelphia, San Francisco, Milwaukee, and Anaheim, retiring from the New York Yankees following the team's World Series championship in 1999.

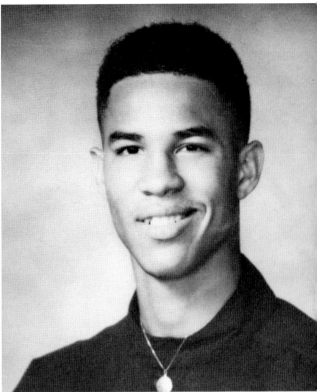

Rick Brunson (1972–)
Brunson grew up in the Collins Cove neighborhood and played basketball for Salem High School, winning a McDonald's All-American Most Valuable Player award. Brunson played for and graduated from Temple University, then signed on as a free agent with the NBA's Portland Trailblazers in 1997. He played on seven NBA teams in nine seasons as a point guard. Brunson's career NBA statistics include 1,090 points, 447 rebounds, and 876 assists. He has coached on various college and NBA teams and, as of 2012, is a coach with the Charlotte Bobcats. One of his abilities is developing strengths and strategy with young athletes. His son, Jalen Brunson, is on the road to becoming a star player. (Courtesy of Paul Plecinoga, Salem Archives.)

Scoonie Penn (1977–)

James "Scoonie" Penn was Salem High School's superstar basketball player. Following graduation, he played for Boston College and then for Ohio State, where he graduated. At Ohio State, he played with future NBA all-star Michael Redd; together, the two Buckeyes formed what many believe was the most dynamic backcourt in college basketball history. Penn and Redd have remained great friends to this day. Penn is currently playing for European league teams. He has played in countries from Italy to Serbia, and he still wows fans with his sportsmanship and expertise in the game he loves. Always a gentleman, and usually smiling, Penn was and still is upbeat and positive, displaying speed and strength on the court and off. He is clearly still the pride of Salem High's basketball legacy.

Bowen Kerins (1975–)
Kerins has been playing at pinball arcades from the time he was five years old, including those in the Salem Willows arcades. He lives in Salem with his wife and family. A room in his house has a pinball machine surrounded by his numerous professional pinball tournament trophies. Kerins earned his bachelor's and master's degrees from Stanford University, and he makes his living as a writer of high school math books. But his avocation and the source of his greatest satisfaction is the competitive pinball tournaments he attends across the country. He has won more than 30 major tournaments, including the legendary Pro-Am Pinball Association in Pittsburgh, where he won the world championship in 2005. (Courtesy of the Pro-Am Pinball Association.)

Brian St. Pierre (1979–)
As a quarterback from Salem, St. Pierre played for Boston College before the NFL's Pittsburgh Steelers drafted him in 2004. In his junior year at Boston College, he completed 149 out of 279 passes for more than 2,200 yards, 25 touchdowns, and 10 interceptions. He distinguished himself in athletics and academics, receiving Boston College's Varsity Club's Scanlan Award. St. Pierre has played with the Baltimore Ravens, Arizona Cardinals, and Carolina Panthers.

Wayne Vernal Milner (1913–1976)
Milner was one of Salem High School's all-state football champions. He played for Notre Dame and was drafted by the Boston (subsequently Washington) Redskins. In his seven seasons, he scored 12 touchdowns and caught 124 passes for 1,500 yards, for an average of 12.7 yards. He is considered one of the NFL's greatest receivers. In 1968, Milner was inducted into the Pro Football Hall of Fame.

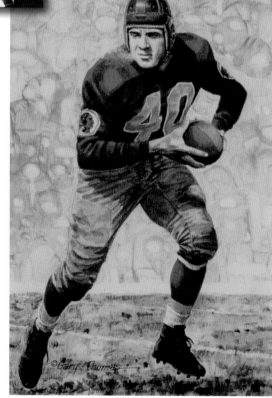

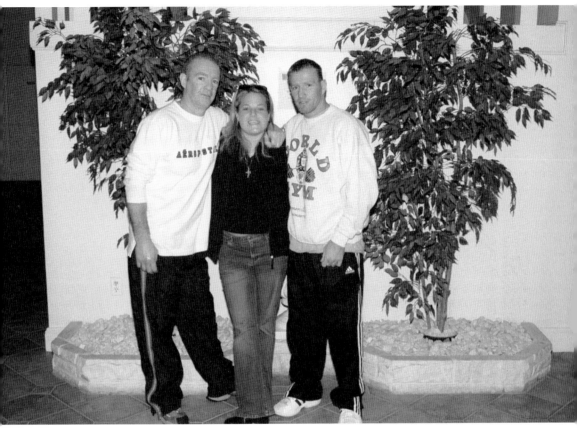

Emily Harney (1980–)
An active Salemite and high school teacher, Harney loves sports and photography, especially the boxing ring. Her loves became an avocation. Sports photography offered her countless opportunities. Her mentor was Dickie Ecklund (left), brother of boxer Mickey Ward (right). The brothers were the subject of Mark Wahlberg's film *The Fighter*. Harney has won numerous sports photography awards, and for her senior thesis at Lesley University, she produced award-winning photographs of Ward honing his boxing skills. (Photograph by Bob Trieger.)

INDEX

LEGENDARY LOCALS

AN IMPRINT OF ARCADIA PUBLISHING

Find more books like this at
www.legendarylocals.com

Discover more local and regional history books at
www.arcadiapublishing.com